IMAGES
of America

SILICON VALLEY

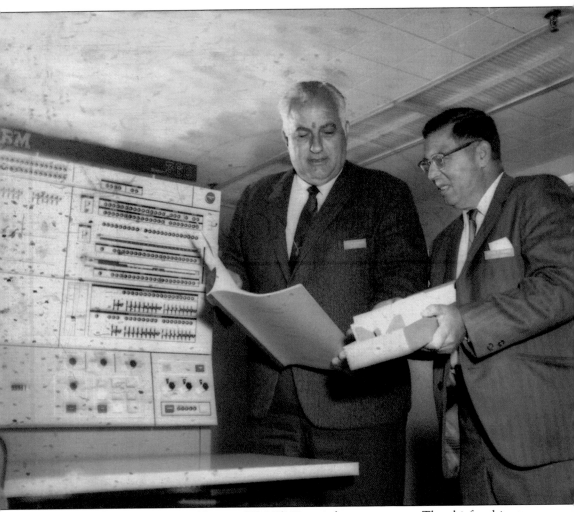

This image was taken in 1965 on an IBM S/360 mainframe computer. The chief architect was Gene Amdahl, who later had his own company in Sunnyvale. At the time of the S/360 product launch, 100,000 businessmen in 165 cities attended the event. Some modified 360s were still in use as late as the 1990s and on military aircraft. (Courtesy of Santa Clara County Archive.)

ON THE COVER: This picture shows a c. 1960 IBM computer at 70 West Hedding Street in San José. The system comes with an IBM 1401 transistorized processor, 1402 key punch card reader (left), and 1403 printer combining features from three separate machines. Behind are five IBM 729 magnetic tape units. The system was used for payroll and account reports. The left gentleman is Edward Glaeser, county controller; the man on the right with a cigar is Karl Sheel, director of data processing, and the woman is unidentified. (Courtesy of Santa Clara County Archive.)

IMAGES
of America

SILICON VALLEY

Sam Shueh
with foreword by Beth Wyman

ARCADIA
PUBLISHING

Published by Arcadia Publishing
Charleston, South Carolina

Printed in the United States of America

Library of Congress Control Number: 2009924699

For all general information contact Arcadia Publishing at:
Telephone 843-853-2070
Fax 843-853-0044
E-mail sales@arcadiapublishing.com
For customer service and orders:
Toll-Free 1-888-313-2665

Visit us on the Internet at www.arcadiapublishing.com

This book is dedicated to my parents, Lee-Tang and Julia.

CONTENTS

ACKNOWLEDGMENTS

As a 31-year resident of Silicon Valley, a valley created by seismic movements raising the Diablo and Santa Cruz Mountains, I have witnessed the transformation of the area from a semi-agricultural base to a world-class technology center. When I see an old building, I wonder who lived there and how they lived. Whenever I hear that a building is being demolished, I quickly bring my camera to document a bit of local history.

I wish to thank Lisa Christiansen of California History Center, Lakehurst Historical Society for information on the Moffett blimps, Jeanine Stanek of the Sunnyvale Historical Society, historian Yvonne Olson-Jacobson, Mary Hanel of the Santa Clara City Library, Steve Staiger of the City of Palo Alto, Masahiko Nishimura of the San José Buddhist Church, and Peggy Schopp of the Saratoga Historical Society. Thank you to Michael Griffith and Trista Raezer of the Santa Clara County Archive and Collie Woodward for helping to identify names shown in the computer photographs. History of San José–Silicon Valley a-z, California Room of San José Public Library staff, and the Navy Historical Center are all greatly appreciated. Without these fine professionals' help, this work would not be completed.

I was pleased to oblige, as some of my engineering work already ended up in the Computer History Museum. I wish to thank Fiona Tang for the permission to photograph the Computer History Museum's exhibit. Permission to use material from Cisco, Intel, and so on is also appreciated. During the preparation, I often met people willing to share their sweet memories who realize the work needs to go on before the history is lost forever. Finally, I wish to thank Beth Wyman, former county commissioner of historical heritage, for her foreword.

During my interviews, many promised to offer their old pictures; I found these photographs were elusive. I was deeply touched as the residents urged me to go on documenting what they know. The images in this book, unless otherwise noted, are from my own collection or provided by another private collection. I also wish to thank Kelly Reed and Devon Weston at Arcadia Publishing for their guidance and Bill Holland and Aaron Sikes for their reviewing and skillful editing. Last but not least, I am grateful to my wife, Lilie, for her patience and understanding of my perseverance. Now she knows why I, a realtor, stop in the middle of nowhere to study crumbling buildings.

FOREWORD

Deciding to compile the history of any place takes a certain amount of self-confidence, as well as lots of time and patience. Determining that the story is complete demands courage because, of course, there is always something more. I commend all who have made the effort. Each perspective adds new dimension to what we understand about the place in which we live.

My congratulations go to Sam Shueh, whose remarkable endeavor has brought together information about Silicon Valley, in addition to his previous book on South Santa Clara County. He worked at IBM San José Research and Storage System Division as a researcher and an engineer. His contributions include much original computer technology and local history research, which helps us to see how the valley changed.

—*Beth Wyman*
Author, *Hiram Morgan Hill* (1990)
Mayor, 1982–1983, City of Morgan Hill
Santa Clara County Historic Heritage Commissioner (1983–1999)

INTRODUCTION

John Muir was stunned by the breathtaking rural beauty of the area. In 1868, he wrote, "It was bloom time of the year. . . . The landscapes of the Santa Clara Valley were fairly drenched with sunshine, all the air was quivering with the songs of meadowlarks, and the hills were so covered with flowers that they seemed to be painted."

The valley used to be the world's largest producer of apples, prunes, and apricots. The sweet smell of fruit flower blossoms wafted over the fertile land of the "Valley of the Heart's Delight." When this author arrived in the area 31 years ago, Santa Clara was a valley of vanishing fruit orchards waiting for the high-technology revolution to be recognized and for more people to plant "silicon" seeds.

It all started with Stanford University. Over the years, Stanford University graduates and affiliates and entrepreneurs like Hewlett and Packard worked out of their garages (HP), creating microwave and radar technology (Varian Associates), the Shockley transistor, a semiconductor to miniaturize the size of integrated circuits (Noyce and Moore/Intel), and microprocessors, which in turn created the personal computer revolution with Apples (also out of a garage) and PCs. Companies like IBM developed the floppy disk and hard drive database. Later it became the integrated circuit computer chip leader. In the late 1990s, followed by proliferation of the use of the Internet, many related technologies were developed, such as Cisco, Netscape (now AOL), and search engine giants like Yahoo, Google, and more. Much of the biotechnology revolution also took place in and around Silicon Valley, with such industry leaders as Genentech and Chiron.

Government and business leaders from all over the world wishing to replicate the success of Silicon Valley have made the obligatory trek to Silicon Valley to see and observe and hopefully capture some of the magic to take home. It is common to go overseas and see another group of technologists start another valley elsewhere. Silicon Valley innovators and business leaders believe in the future and accept the roller-coaster business cycle, along with potential rewards and risks.

Silicon Valley has earned universal recognition as the mecca of high-technology and venture capitals. The valley was once also a center for aeronautic research and rocket booster development supporting World War II and later most of the space missions. Moffett Airfield was intended as a base for navy dirigibles and ended up as NASA and Lockheed, which routinely invent new technology. The valley was linked to the outside initially by the railroads built around 1869, then by highways such as I-101, I-17, I-85, I-280, I-680, and I-880, and now by abundant fiber-optic cables and wireless routers.

This is a regional book. It involves research of many municipalities within Santa Clara County. It is divided into six chapters: Birthplace of Silicon Valley, East Gateway of Silicon Valley, the Heart of Silicon Valley, the Silicon Capital, Public and Transportation Service, and Silicon Valley Events. The work is monumental as it involves in-depth research to correctly identify the location and events from the old images. I made attempts to return to the same spot trying to get a modern image in most cases. Often I found the trees and new tall buildings obstructing original views, forcing me to shoot photographs from a different direction.

Despite the rapid population growth that brought 165,000 high-technology workers, the valley has retained her natural beauty with abundant sun, mild weather, and close proximity to the ocean. It is difficult to find another place as desirable as Silicon Valley. Many residents would agree this is their "Valley of the Heart's Delight."

One

BIRTHPLACE OF

SILICON VALLEY

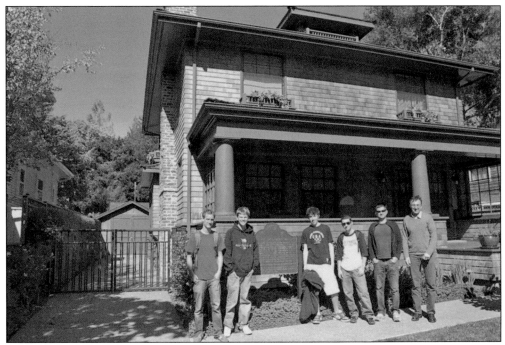

In this garage in 1938 on Addison Street in Palo Alto, William Hewlett and David Packard developed their first product. Whether to use an "HP" or "PH" company name was decided by flipping a coin. Three years later, HP had three employees and eight products and generated $34,000 revenue.

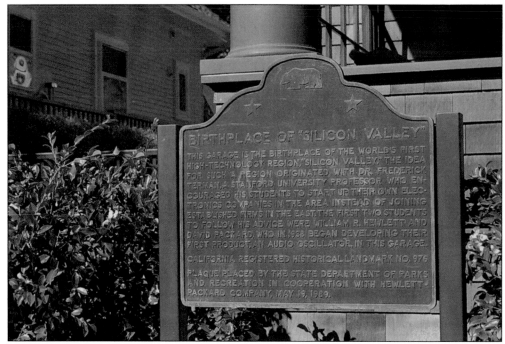

HP headquarters is located at 3000 Hanover Street in Palo Alto. HP's instruments were famed for their solid design and accuracy. Walt Disney Studios ordered eight sets of audio generator HP200a at $71.50 each to test its audio cartoon *Fantasia*. The instrument division of HP was not long ago spun off as Agilent. In 1999, the company made $2.1 billion, which is a lot more than the $538 they started with in 1938. In 2007, HP reported revenue of $104.3 billion with over 172,000 employees.

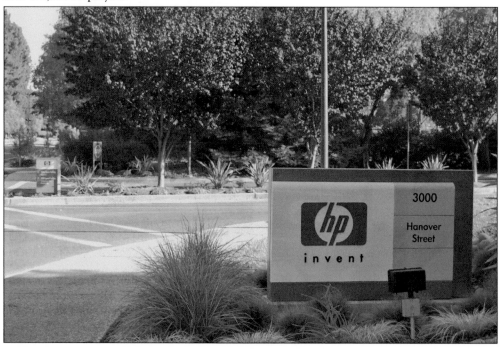

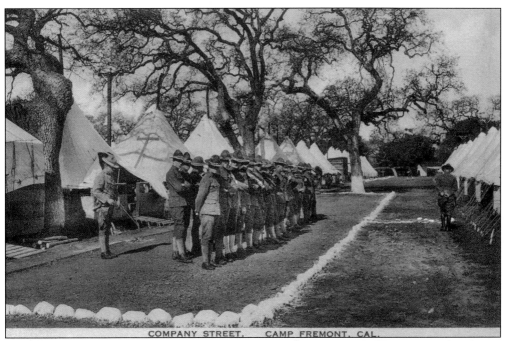

COMPANY STREET. CAMP FREMONT. CAL.

Army soldiers are shown above in formation in Camp Fremont, Menlo Park, around 1918. The area served as a military camp between July 18, 1917, and December 19, 1918, on a 7,203-acre pasture. The 8th Division soldiers were trained to fight in France. It had up to 27,000 enlisted men at the camp. Most soldiers spent the rest of the war physically fit. However, those sent to fight in Siberia during the Russian civil war suffered frostbite and deaths. The photograph at right depicts a victory parade on University Avenue. It was in the middle of a deadly influenza, and soldiers wore gauze mask to protect themselves. Little is left of the original camp. The Oasis Beer Garden today was once the site of a 1917 YMCA for soldiers and their visitors, and a base hospital on Willow Street became the VA Hospital. (Courtesy of a private collection.)

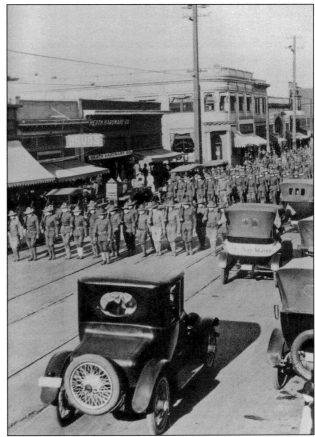

Menlo Park has played a major role in Silicon Valley. A number of venture capital firms set their offices prominently along Sand Hill Road (for example, 3000 Sand Hill Road had almost 50 firms). Compared to similar office rentals' cost, the square footage on Sand Hill Road was the most expensive place globally in 2002. The Stanford Research Institute (SRI) on Ravenswood Avenue routinely spun off business from technology they had developed. Lately, its core business is robotics, biomedicine, and fuel cells. The city is also known for the Stanford Linear Accelerator Laboratory (SLAC), a basic research lab in elementary particle physics with the world's longest particle accelerator to collide atomic electrons and positrons. The world's first Web site was developed for SPIRES-HEP in 1991; the site still provides search and help features.

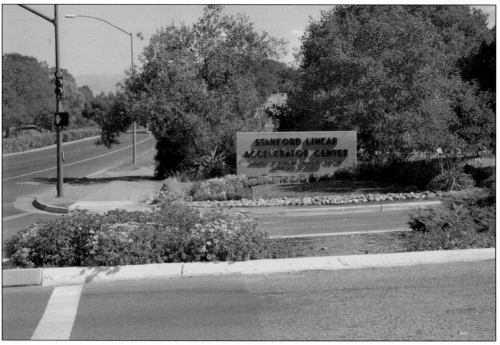

The right photograph is of coastal redwood and is the site where the 1769 Portola Expedition camped. El Palo Alto was already 843 years old. Many roads like El Camino Real were measured from the center of the tree trunk for mapping by surveyors. The original tree had twin trunks and grew to 162 feet in 1814. However, due to either the construction of the Southern Pacific Bridge or heavy rain in 1886, the left trunk toppled. The height of the right trunk was trimmed back to 110 feet with termite treatments, mist spraying, and fertilizing. It was cared for by Woody Metcalf, a forester, for 40 years. Today's tree shown here is considered healthy, and its seedlings have been planted on the Stanford campus. El Palo Alto is designated as California Historical Landmark No. 2.

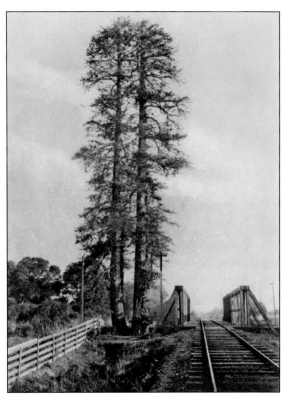

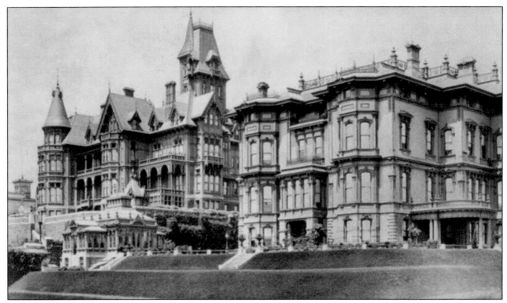

Leland Stanford came to California during the Gold Rush. He soon became a politician and ran for governor. Later Stanford became president of Central Pacific Railroad and was instrumental in connecting the eastern United States and California with a railroad completed in 1869. His wife, Jane Lathrop, and son, Leland Jr., lived in a plush 19,000-square-foot magnificent mansion surrounded by Powell, Powell-Pine, and California Streets in the Nob Hill district of San Francisco, shown in the 1887 photograph above. The Stanford home served as the state capitol briefly and was later sold by Jane Lathrop to pay for Stanford University's operating expenses. The family also owned a 650-acre Palo Alto farm, named after the famed redwood tree. On weekends, the family relaxed on the farm, as would many prominent citizens at the time. The photograph below was taken in the mid-1910s. (Both courtesy of San Francisco Library.)

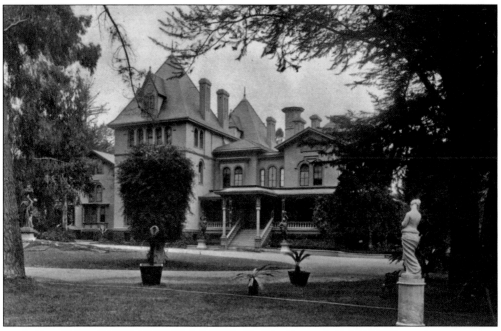

In 1884, Leland Stanford's son died of typhoid in Europe. That same year, the family endowed $20 million to build a world-class university by purchasing 8,200 acres for the campus, shown at right with this family statue. Leland Sr. passed away two years after the school opened. Jane Lathrop Stanford, a friend of Susan B. Anthony, admitted both non-Caucasian and women students. The photograph below depicts a northbound train steaming toward El Palo Alto around 1894, which is behind the Palo Alto Hotel on Alma Street. The building on the right is the Bank of Palo Alto. The circular corral is now named the University Circle; University Park was the original name of Palo Alto. Stanford was on the left side and was barely one year old.

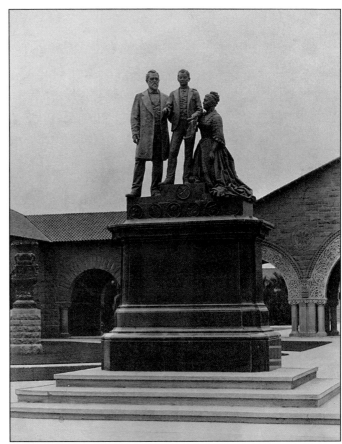

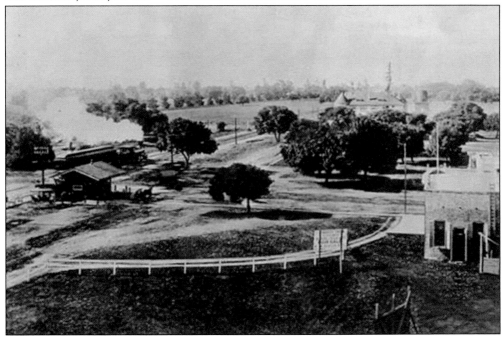

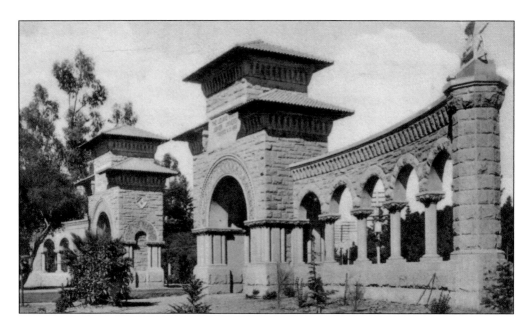

Here are two views of the main entrance to Sanford University. The photograph above was taken in 1900 and highlights the ornate details of the archway. The Stanford family hired Frederick Law Olmsted, the famed architect who created New York's Central Park, to develop the master plan for the university. It opened on October 1, 1891. Students would take the Southern Pacific train, which had a station in front of the university. The former entrance is barely recognizable in 2008 as the grander side-arch walls were replaced after the 1906 earthquake with short concrete blocks. The new gate shows a less grandiose structure.

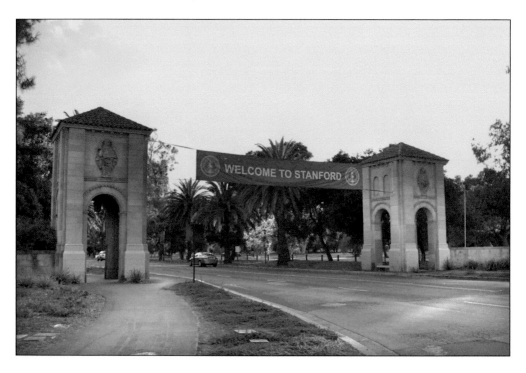

This is a 2008 view of Palm Drive leading into the heart of the Stanford University campus. Palm Drive begins at El Camino Real and runs through the gateway arch shown previously. The drive ended at the Oval Park in the heart of campus. Very few people realize today that Leland Stanford Sr. used to raise harness racing trotters where the park is today.

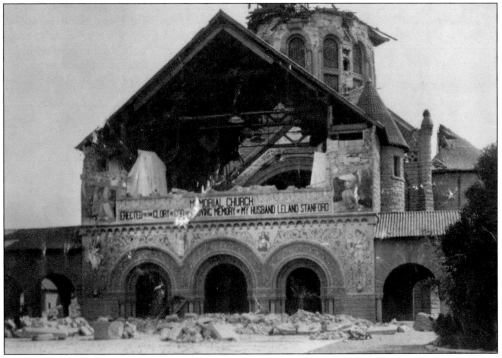

The end of Palm Drive meets Memorial Arch and Memorial Court leading into Stanford Memorial Church. The church was dedicated to Leland. It was built in the style of Richardsonian Romanesque architecture with a masonry facade and deep windows. It had massive columns, a round arch built of natural stones, mosaics, and paintings of female characters and figures. As shown in this photograph, most structures were damaged in 1906. The restored church (not shown here) was not rebuilt until 1911. (Courtesy of a private collection.)

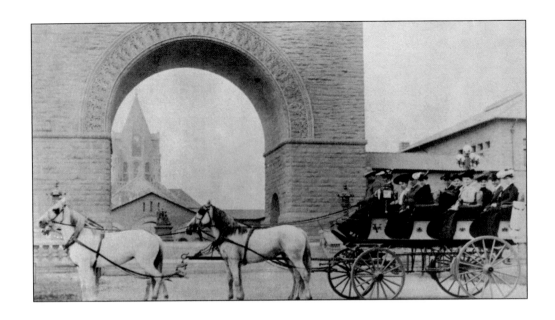

The 100-foot-tall arch was erected in 1902 at the entrance to the Main Quadrangle leading into Memorial Court by Charles Lodges and Pupert Schmid. During the 1906 earthquake, the upper right side toppled. The remaining columns were later capped by red tiles. They are shown in this state in the photograph below. The plan to rebuild the original arch was shelved. In 2008, an overgrown tree necessitated the photographer to capture the view from the Memorial Church side facing towards the two columns, opposite that of the picture above.

Pres. Herbert Hoover was a first-year alumnus (1895) from Stanford. While working overseas, he assembled a vast collection of French Revolution materials consisting of 1.4 million titles in 1929. To house his collections, a 285-foot tower was built in the art deco style by Arthur Brown (who also designed Coit Tower). The Hoover Tower was completed in 1941. Today the Hoover Institute is dedicated to research of war, revolution, and peace.

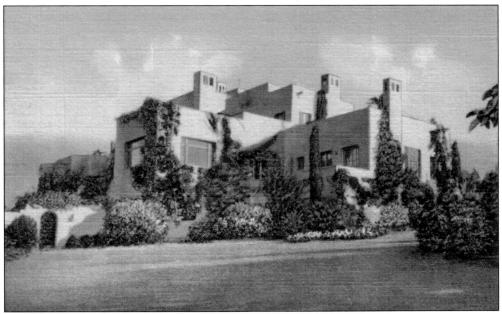

The three-story Hoover home was built in 1920 for former president Herbert and Lou Henry Hoover. It is constructed in the mission pueblo style on San Juan Hill with parts of the house hidden. The family lived there before Hoover's election to the presidency and later after he was defeated by Franklin Delano Roosevelt. President Hoover deeded the house to the university as the Stanford president's home in 1941.

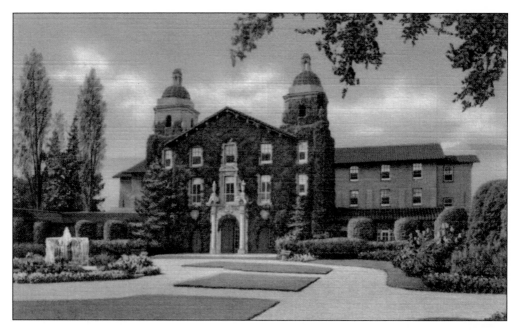

Two views of the Stanford Union Complex are shown. The complex consists of buildings constructed from 1915 to 1923 as a women's dormitory and the first campus student union. It is constructed in the Spanish Colonial Revival style, connecting three buildings together with arcades. It had an Ivy League appearance in this 1930s linen postcard. In 2006, a $24 million face-lift restored the original appearance. The refurbished Old Union complex features a large lounge space, the Axe-Palm café, and meeting rooms for student groups. Two smiling workers posed in front of the Old Union.

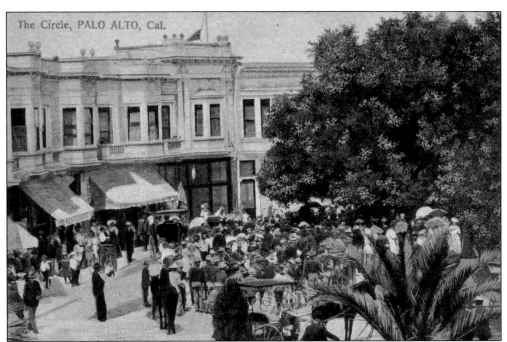

The Circle, PALO ALTO, Cal.

Adjacent to Stanford University is the city of Palo Alto where El Camino Real and Alma Street meet. During the early part of the 20th century, Palo Alto had a circle in front of Alma Street. A number of commercial buildings once stood by the circle. In 1906, a giant flagpole was erected on the northwest side and the circle was the rendezvous point for residents. Due to the passing train, and heavy traffic in and out of Stanford, an underpass was constructed and completed in 1941. Gov. Culbert Olson delivered a speech at its opening ceremony. Today there is a U-shaped park cut through by the underpass roads and commuter train roundabout.

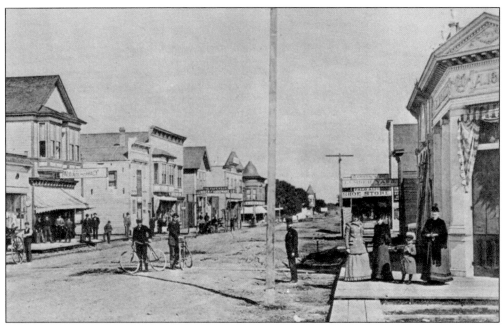

By 1894, the village sprouted many commercial buildings along University Avenue. This is a southwest view from the Bank of Palo Alto near 116 University Avenue, an office building today, at the corner of University Circle and University Avenue. The Halls Drug Store was on the left side. Like most western towns, planks were installed as sidewalks to avoid the dusty and muddy streets. This photograph depicts the Palo Alto Pharmacy, Lumber and Hardware, and Hill and Yard Photographs between High Street and Emerson. The dome building on the left was the Ledyard Building. The area has been mostly been rebuilt. The lower picture was taken at High Street and University Avenue facing towards the circle.

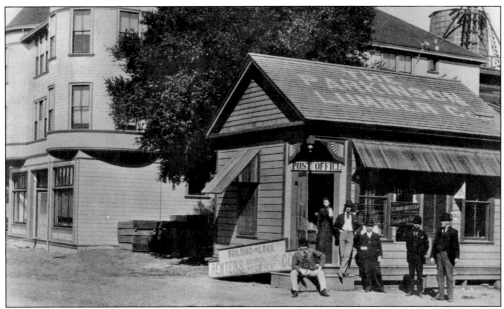

J. F. Parkinson came to Palo Alto as a businessman. In 1893, he operated a hardware and lumber business on University Avenue between High Street and Emerson next to the Ledyard Building. His business prospered, and he soon opened the Bank of Palo Alto. Later he was involved in setting up the first school at the corner of Bryant Street and University Avenue and donated material for a church among other charitable contributions. The photograph above shows his lumber business. Parkinson was also in the lending and real estate businesses and managed a post office. The 1894 signs outside indicate that he was an agent for the Firemen Fund, that he welcomed German Americans, and that he was a newspaper distributor. It is no surprise that he became a local mayor later. The picture below, from around 1920, shows a building that was named after him. (Both courtesy of a private collection.)

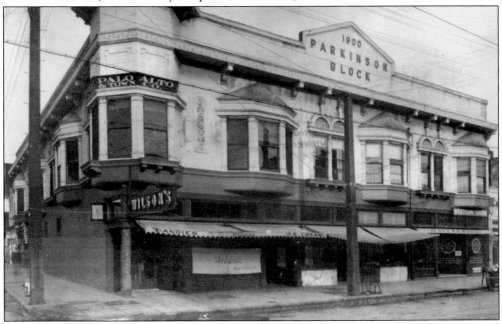

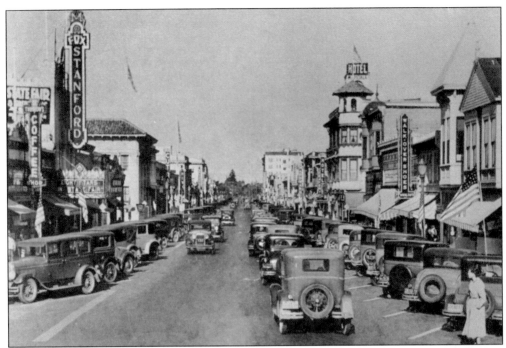

These photographs are of Palo Alto looking east from the corner of Emerson and University Avenue. Stanford Theater was founded in 1925. This picture depicts the 1933 movie *State Fair* with Will Rogers and Janet Gaynor. It is amazing that parking was even more congested 75 years ago. Automobiles had to park at an angle to save space. In 1987, the David and Lucile Packard Foundation purchased and restored the neoclassical Greek/Assyrian-style building. Today it features old films from the 1920s to 1960s.

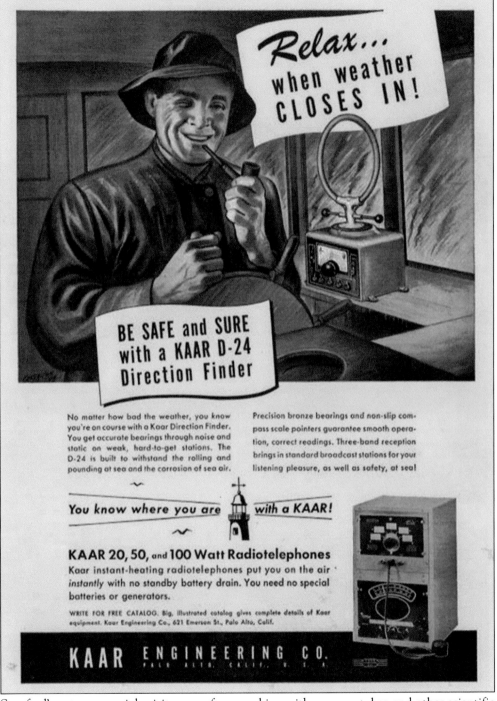

Stanford's entrepreneurial spirit comes from working with vacuum tubes and other scientific inventions. This 1947 advertisement from Kaar Engineering showed an earlier directional finder called a radio telescope for airplanes and ships alike. It detected three different radio beams and calculated the finder's location. The Japanese used a similar method to launch the attack on Pearl Harbor. It was by then an effective navigational instrument.

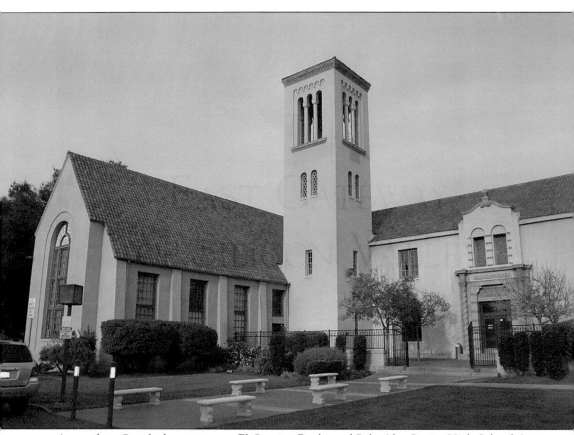

Across from Stanford campus over El Camino Real stood Palo Alto Senior High School. It was founded in 1898. Being close to the heart of Silicon Valley and Stanford University, the school drew high-achieving intellectual students. It ranked in the top four percent of American public high schools. It is also strong in sports like basketball and football.

Two

EAST GATEWAY
OF SILICON VALLEY

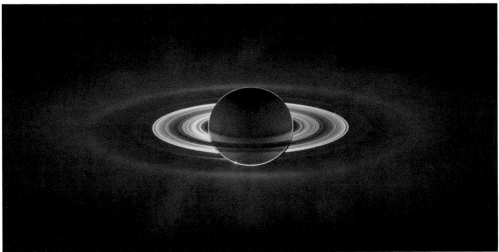

Here is a rare photograph of an eclipse of Saturn taken through the Lick Observatory telescope. A fifth moon was discovered using the 36-inch telescope in the 19th century. It had been three centuries since Galileo's claimed discovery of the first four moons. Currently Saturn has 60 moons while its neighboring planet, Jupiter, has 63 moons revolving around it. The last 23 moons, some as small as 1 kilometer in diameter, were all discovered in 2003. (Courtesy of Lick Observatory.)

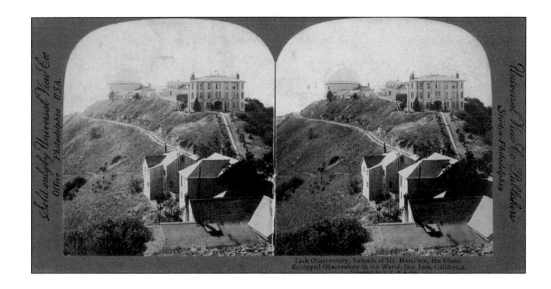

James Lick was at one point the wealthiest man in 19th-century California. His portfolio contained orchards, mercury mines, and flour mills. He also owned Catalina Island and most of the real estate surrounding Lake Tahoe, as well as parts of Los Angeles. Almost all institutions and buildings in the area today bearing the name "Lick" were at one point owned by James. Lick deeded his fortune for public use. He was talked out of building an enormous pyramid in San Francisco, instead using his fortunes to build a "most powerful telescope and a suitable observatory." Lick Observatory, completed in 1887, is an example of his largesse. It was the world's first permanently occupied observatory. The photograph above is an early-20th-century stereo-card depicting the complex. The card pictured below shows the original 12-inch telescope.

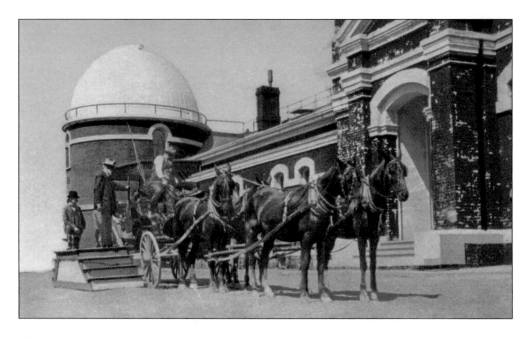

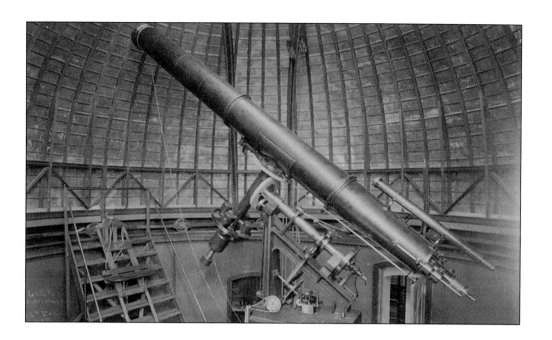

All the construction materials had to be brought to the site by horse-drawn wagons, and a road to the site had to be built. Chinese laborers provided most of the manpower for construction. It took 360 turns to reach the top. The images here shows visitors at the Smith Creek Hotel on Mount Hamilton Road, a carriage arriving, and another carriage departing the main building. (Both courtesy of a private collection.)

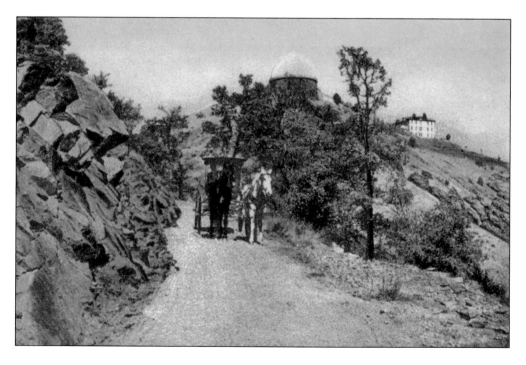

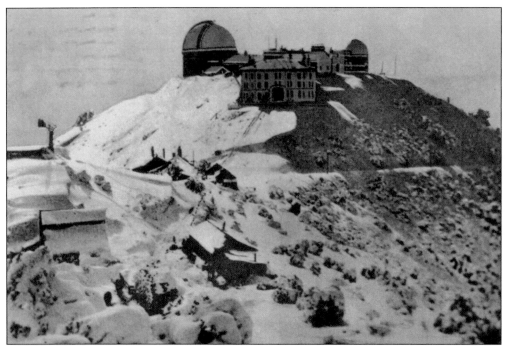

The peak of Mount Hamilton is 4,209 feet above sea level and receives snowfall a few times each winter. Silicon Valley residents always cite the snow as an assurance the valley is cold, as the ground rarely receives snow. The photograph below is the observatory before 1907. The horse corral is now a parking lot. At such an elevation, one can still pump groundwater with a windmill.

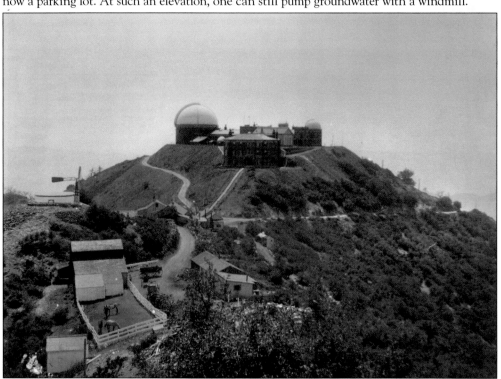

The Great Lick, a Crossley 36-inch reflector, has been in continuous use since 1879. The observatory has added many more telescopes since. The most powerful scope is a 120-inch Donald Shane three-in-one reflector. It was donated by a local seamstress. Several moons of Jupiter and exoplanets were discovered there.

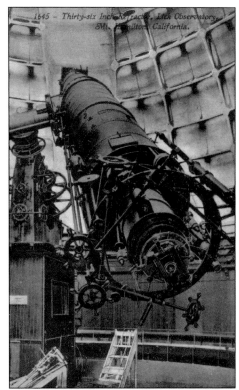

The view from Mount Hamilton is magnificent. At 6:11 a.m., the moon is disappearing on the right. The lights from Silicon Valley are still lit. The fog covers most of the valley, and the peninsula stretches north to San Francisco. Lick today continues to be at the forefront of astronomical research. (Courtesy of Lick Observatory Hamcam No. 1.)

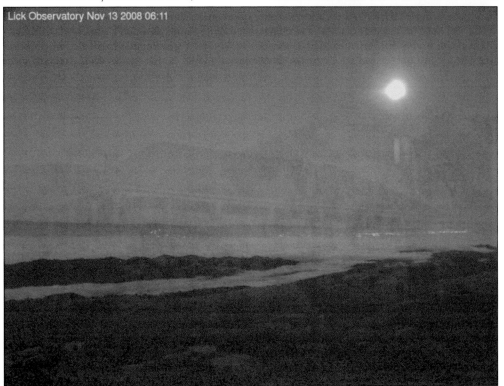

Lick Observatory Nov 13 2008 06:11

Milpitas was a ranch name granted to José Alviso, a descendant of the Anza Expedition Party. José Higuera built an adobe on his land in 1830. In this hybrid building, Higuera's adobe is shown below the wooden hotel owned by the Curtners. Today there is a replica building at Higuera Adobe Park. Local streets are named after these pioneers. (Courtesy of Alice Hare.)

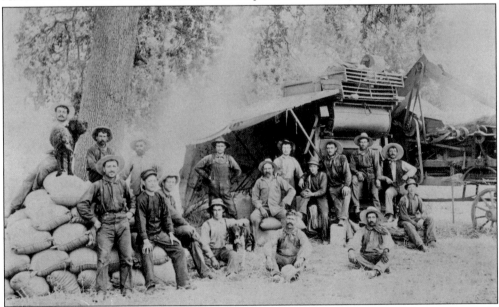

On the farms of the late 19th century, gasoline-powered engines began replacing men and animals. This c. 1925 photograph shows workers posing in front of a barley thresher in the Evergreen District. For his novel *Of Mice and Men*, John Steinbeck drew upon his experience as one of these workers. (Courtesy of P. Tully.)

During the 1830s, James Forbes (who also founded the city of Los Gatos) purchased 1,939 acres of land and built an adobe home near present-day Milpitas. By 1910, only two walls of the original adobe were standing, as shown above. In 1849, Matthew Dixon came to California. He wed Eliza Whisman, a resident of Mountain View. Together they grew wheat and hay. To transport his grain goods to San Francisco, Dixon built pilings along the Coyote Creek Channel to allow schooners to unload the goods. Their son, James Dixon, managed the Cupertino Store (see page 79). Today Landing Access Road remains the entrance to the east gate of Silicon Valley. Not much is left from the early days except this c. 1930 photograph showing a lone home standing by the east foothills. (Both courtesy of the California Room.)

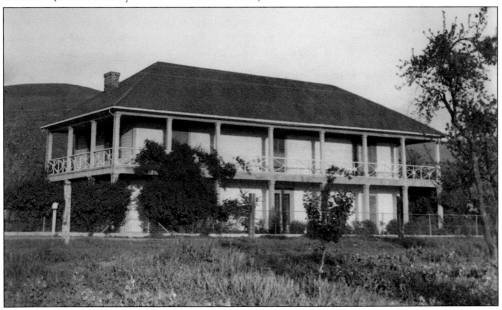

Here is a rare 1920 photograph of the Chinese team working on an onion farm between Dixon and Scott Creek Roads east of today's I-680. The hats worn are of the Cantonese fishermen type. In this area, laborers were once exclusively Chinese. In an 1870 census, most Chinese indicated their profession as "strawberry growers" if they were male or "prostitutes" if they were female. Some Chinese in San José worked as "woshman." Asians had to wear their best clothes when selling or doing business with their Anglo customers. The lower photograph depicts the Sakauye family delivering their strawberry crops to the Milpitas Train Station.

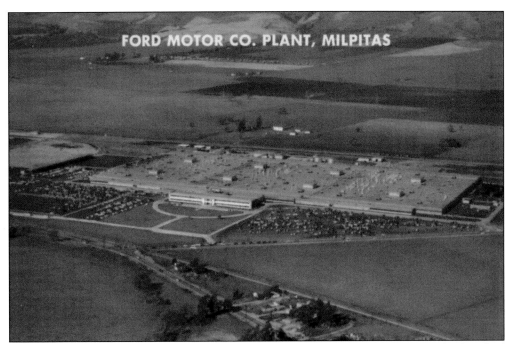

FORD MOTOR CO. PLANT, MILPITAS

For the first half of the 20th century, Milpitas was a little sleepy town with only a few hundred residents. In 1952, Ford set up a local car plant north of San José in what is now Milpitas. The company purchased 160 acres from the Wrigley family, known for their chewing gum products. The influx of up to 6,000 employees resulted in a surge of residential growth. Ford rolled out 4.6 million Mustang cars and trucks for almost 30 years. The jobs provided a boom in city growth. People rallied, and Milpitas became an independent city in 1954. The plant was closed in the 1970s and became the Great Mall.

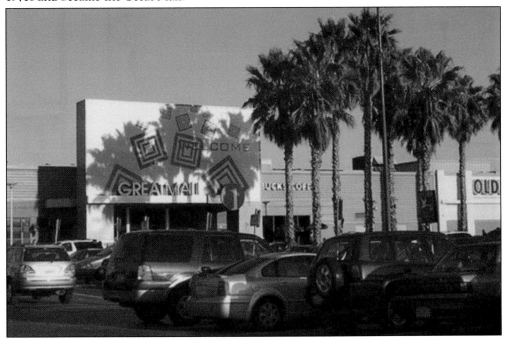

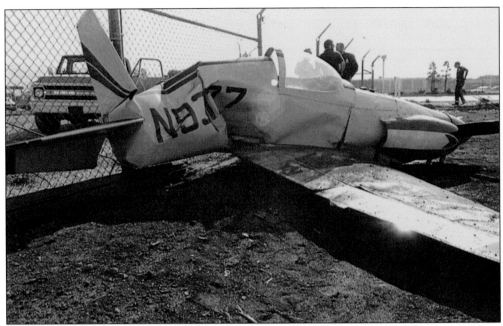

Located at the intersection of Capitol and Tully Roads, the Eastridge Mall, when completed in 1970, was the largest mall on the West Coast. With over 1 million square feet of retail space, it served the needs of Silicon Valley's east side. Reid-Hillview Airport borders the north side of the mall, which can be precarious as shown by the wreckage of a small plane in the mall parking lot above. As a busy street, the area is often used to stage strikes. In 1968 (below), people would gather to demonstrate on issues ranging from low wages to not wanting to vote by mail.

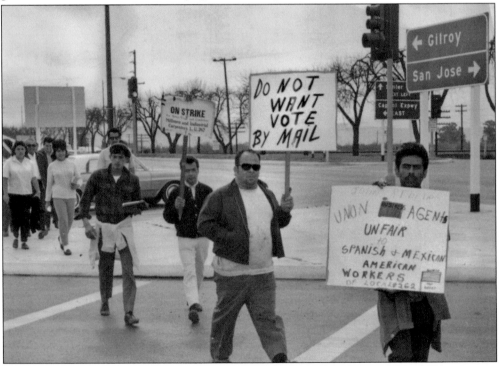

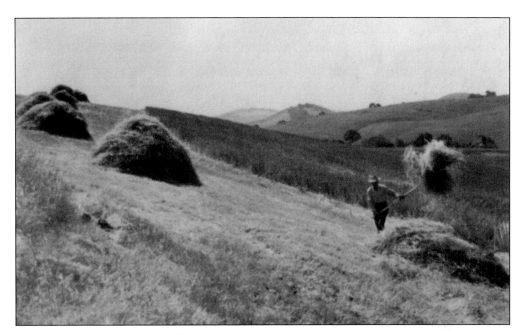

The pioneering landowners in Silicon Valley sold their farms, and now street names carry their original owner's name. Farnsworth, Hassler, Tully, and Hellyer are some of the major streets. This photograph, taken around 1940, is of an Evergreen district farmer working on the Hassler land. John and Gottlieb Hassler, both German immigrants, came to the area, and together they owned 772 acres of hillside land in 1852. Today the parkway leads into a substantial development of custom homes, schools, and a golf course that replaced the once-rural and sparsely populated Evergreen area.

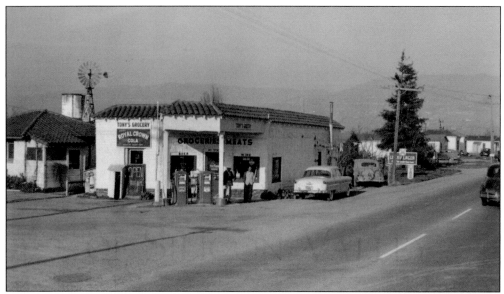

East San José was the name of a small former city that was annexed by the City of San José in 1911. It is rich in culture with many ethnically diversified groups. Here is a 1954 East Capitol Road image showing the neighborhood. Many homes were built after World War II, when housing developments were booming all over the Santa Clara Valley. Gone are some of the water tanks and windmills. (Courtesy of Santa Clara County Archive.)

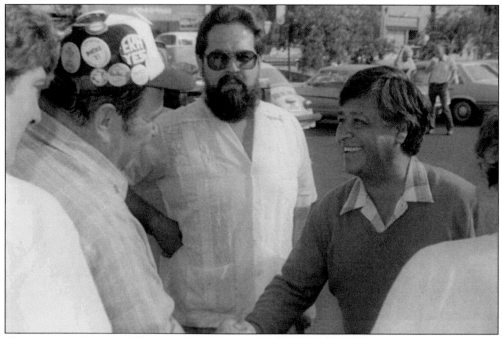

The Mexican Heritage Plaza is a unique community and cultural arts facility located at the corner of Alum Rock Road and King Road in San José, in the heart of the area where Mexican Americans settled in San José in the mid-19th century. Cesar Chavez and his followers staged boycotts for the farm workers at a former grocery store. Seen here is a c. 1982 photograph of his visit in San José. (Courtesy of Santa Clara County Archive.)

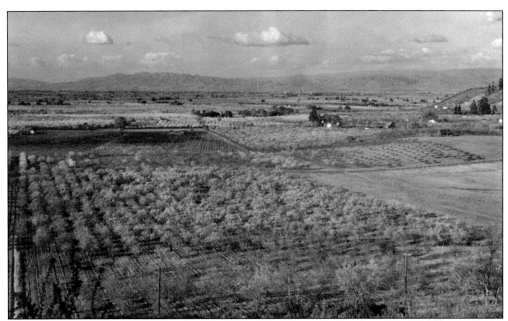

The Valley of the Heart's Delight was a name given because of the fruit trees grown here. Above is a rare view of the valley in an undated photograph. One can see miles and miles of flowers blooming when the area's industry was based on agriculture. Communication Hill is shown on the right side. Today on a hazy day, Silicon Valley resembles what it looked like before it changed. The photograph below was taken, slightly east of the image above, from Sierra Road in 2008. (Above, courtesy of Santa Clara County Archive.)

San Jose, Cal., Mch 29 1890

Evergreen Dist -

BOUGHT OF E. H. Guppy & Son,

Booksellers and Stationers.

Jan	15	3 Gro Pen 2 25 2 Phys Cap 4 00	6	25	
		1 Qt Ink 65 1 Gro Pencils 2 00	2	65	
Feb	15	Drawing Paper 1 00 1 Gro Col Chalk 1 25	2	25	
		3 Doz Report &c 75 Envelops 35	1	10	
		1 File		25	
Mch	15	4 Gro Chalk 60 3 Gro Pen 1 50	2	10	
		1 Gro Penholder 1 00 1 Gro Pencils 2 00	3	00	
		Slate Pencils 20		20	
	19	2 Doz B.B. Erasers	5	00	
Mch	26	1 Phys Env	15	22	70

In 1890, Evergreen was a hilly pasture dotted with cows and orchards. The school district had a rural setting. Here is historical evidence of the school's expenses. It spent only $22.70 on stationery the first quarter. Affluent neighborhoods served by excellent schools have quickly replaced the orchard and dairy farms. Silver Creek Valley, named after an East Hill quicksilver mine, is dotted with gated estates and Mediterranean contemporary monster homes.

Three

THE HEART
OF SILICON VALLEY

Present-day Mountain View was established on the site of Lope Ynigo, a Native American–owned rancho. Originally named Mountain View Ranch, the area was first home to many dairies and seed-growing farms. The town began as a stage stop on the route between San José and San Francisco near today's Grant Road. With the coming of the railroad, the center of town eventually moved to Castro Street. Residents from the 1950s recall going to the Monte Vista drive-in theater and the Eagles Shack dances.

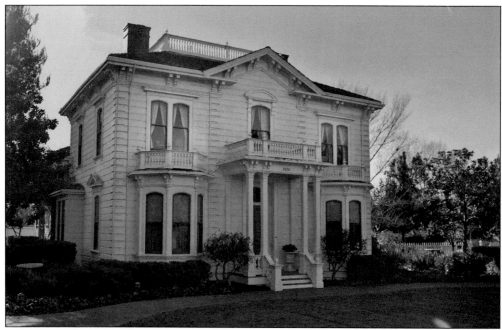

Missing out on the prosperity of the Gold Rush, Henry Rengstorff worked on a steamer between Alviso and San Francisco. He realized the potential richness of the South Bay's fertile land and made a fortune in real estate. In 1864, he built a 12-room Victorian-Italianate house north of the Bayshore Freeway. Shown above is the restored home, which is now located at 3070 North Shoreline Boulevard. Today the Rengstorff House is surrounded by a lake that offers sailing, a bird sanctuary, and wetlands. The museum's water tank and windmill are shown below. Rengstorff is also credited for his contribution that helped to establish Whisman School.

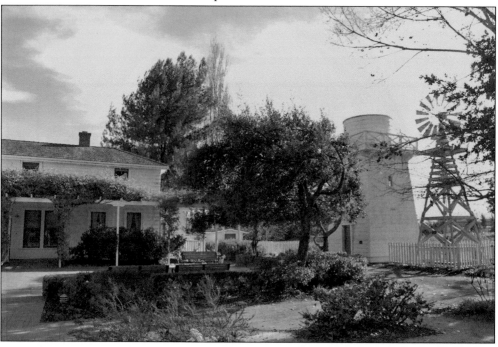

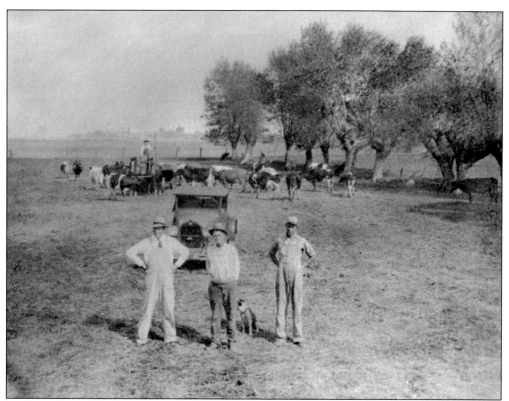

The Mountain View area was known for orchards, hay fields, and farms, as shown in the picture above. The U.S. Navy was looking for a West Coast site to base its dirigibles. A 1,000-acre site was selected east of Mountain View and purchased in 1931 for $476,065.90 with local government backing to help with high unemployment during the Depression. President Hoover, who was familiar with the area, suggested and quickly approved the proposal, and Moffett Field was then born. (Both courtesy of California History Center.)

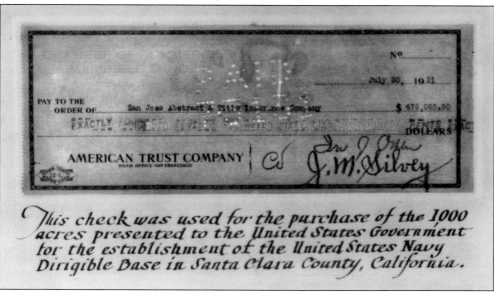

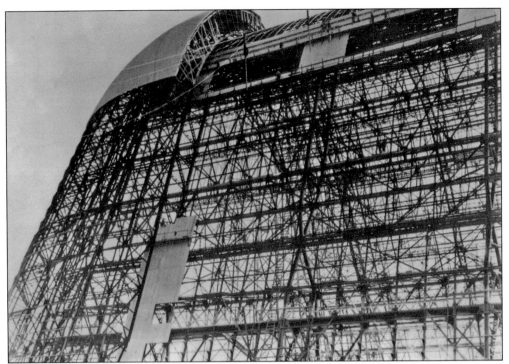

Hangar One was the showpiece of the dirigible base at Moffett Field, where it became the home for newly constructed dirigibles. It was constructed on a network of steel girders sheathed with galvanized steel. The structure is attached to a reinforced foundation anchored to concrete pilings. The floor covers an area 10 football fields in size, and the hangar measures approximately 1,140 feet long, 308 feet wide, and 211 feet tall. The giant metal gates are unique and spectacular, weighing 500 tons each. (Both courtesy of Navy Historical Center.)

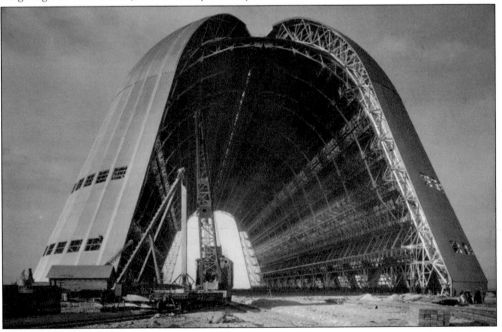

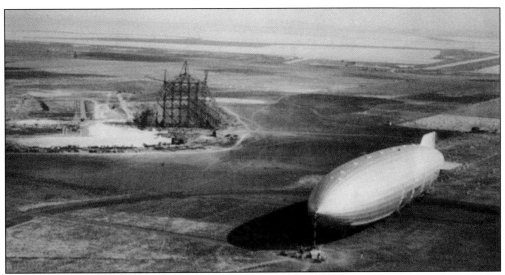

The *Akron*, the U.S. Navy's first airship, was built using helium-filled gelatin-latex cells, advanced technology in airship design. Improved structural technology offered better maneuverability, and the propellers were also able to move in several orientations. The airships also carried several scout airplanes. The *Akron* could carry 20,000 gallons of fuel and hundreds of crew members over an 11,000-mile journey. Christened by Lou Henry Hoover in August 1931, the *Akron* left Lakehurst, New Jersey, on May 8, 1932, and set out for Sunnyvale. These photographs show the *Akron* flying before and after completion of Hangar One. A year later, while flying over New England, the airship encountered a storm and crashed, resulting in 73 deaths. Among those killed was Rear Adm. William Adger Moffett, the most supportive advocate of lighter-than-air dirigibles. (Both courtesy of Navy Historical Center.)

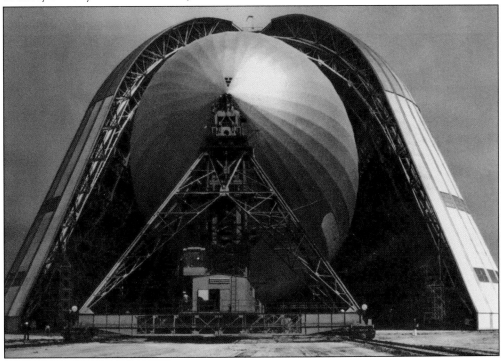

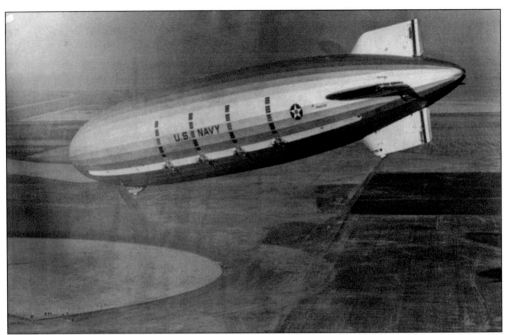

The photograph above shows the *Macon*'s maiden voyage to Moffett. People lined up to greet her arrival. The USS *Macon* was the second dirigible stationed at Moffett Field. Her mission was to demonstrate her scouting capability, and she became a familiar and popular sight in the Bay Area. She had plenty of advanced features and could cruise at 76 knots. Once she had landed, the dirigible's nose was tied to a mobile hitch to anchor it down. Its unique method of releasing and retrieving small F9C Sparrowhawk scout planes made it a sensational topic among Bay Area residents. Many people in the valley still remember the dirigibles to this day. (Both courtesy of Navy Historical Center.)

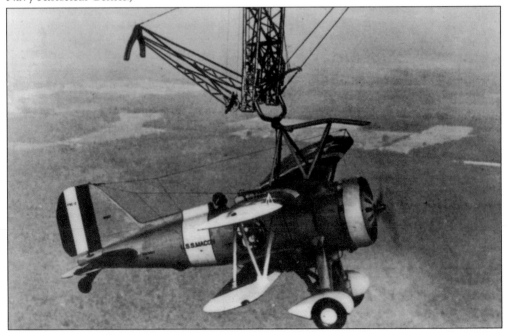

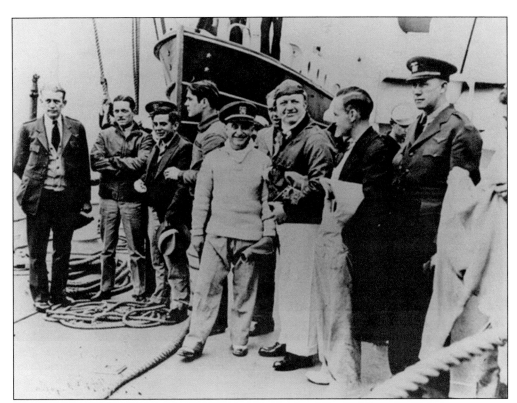

Here are some of the *Macon* crew members after being rescued from the crash site off the California coast at Sur Point. They seem to appear relieved, with few casualties. This loss of the last airship *Macon* forced the navy to reassign the mission of Sunnyvale Naval Base. Hangar One was subsequently used as a base for different missions. It once housed the entire squadron of Boeing F3B light fighter-bombers in the 1930s. Only 73 of the F3B planes were built. Under the direction of naval aviation, Moffett Field became a strategic naval airfield. (Both courtesy of Navy Historical Center.)

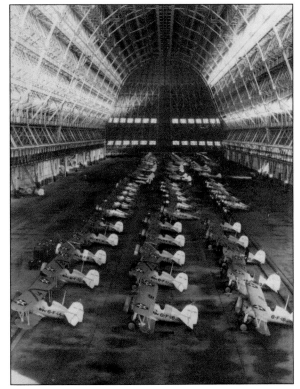

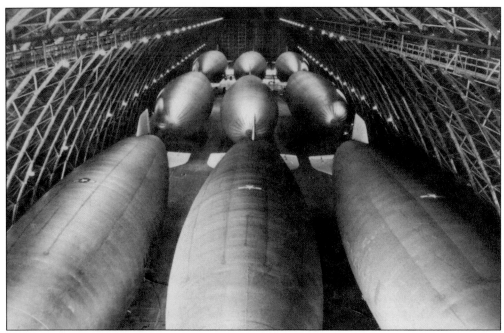

Hangar One later became home to the lighter-than-air (LTA) reconnaissance balloons. The U.S. Navy used both motorized and kite balloons for many years. The motorized balloons were intended for observation and tactical towing. The kite balloons were used for training airship pilots and were still in use until the 1950s. Motorized balloons (above) and kite and motorized balloons (below) are inflated with helium inside Hangar One at Moffett Naval Base in Sunnyvale. (Both courtesy of Navy Historical Center.)

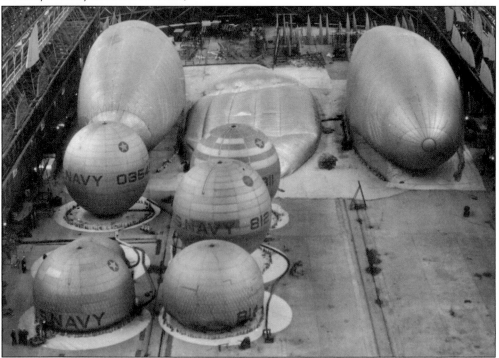

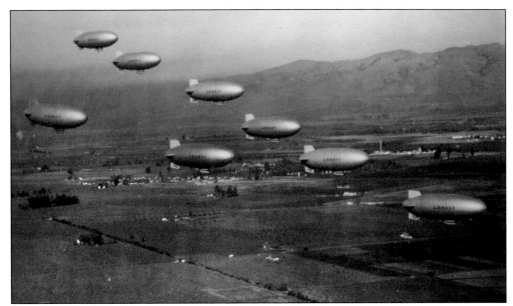

Above is a squadron of nine motorized balloons flying in formation over First Street in San José. This photograph, showing the east foothills, was shot from the ninth balloon. From 1942 until 1945, a total of 154 airships were built for the U.S. Navy (133 K-class, 10 L-class, 7 G-class, and 4 M-class). They were used for scouting and directing ship traffic coming and leaving the bay. The anticipated attack from Japan did not happen. The photograph below was taken in the 1940s. It shows a kite balloon, in front of Hangar One's gate, towed by enlisted sailors who are getting it ready for a mission. (Both courtesy of Navy Historical Center.)

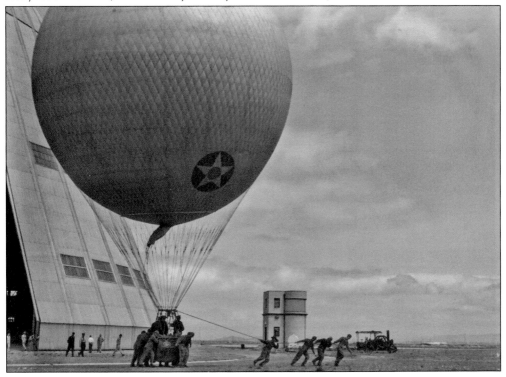

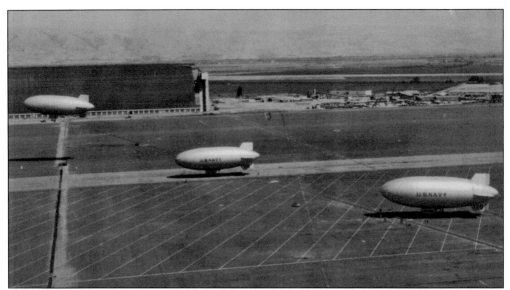

During World War II, as many as 20 blimps were stationed at Moffett Airfield, and Hangar One proved too small to accommodate all of these lighter-than-air ships. In 1942, two more hangars were constructed on the base next to the airplane runways. Construction of Hangar Two was completed in 372 days. Hangar Three only took 208 days to construct. Both hangars were built from wood and concrete materials, as the steel material used earlier had become scarce thanks to the war effort. The photograph above shows Hanger Two and three motorized balloons, which were used for training airship pilots. The balloon at the far left was already launched while the other two were about to lift off. The picture below shows bombers in an undated photograph. (Both courtesy of Navy Historical Center.)

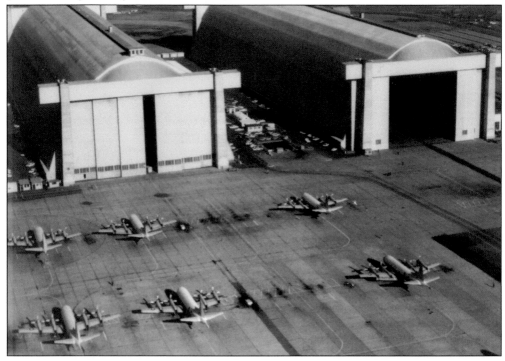

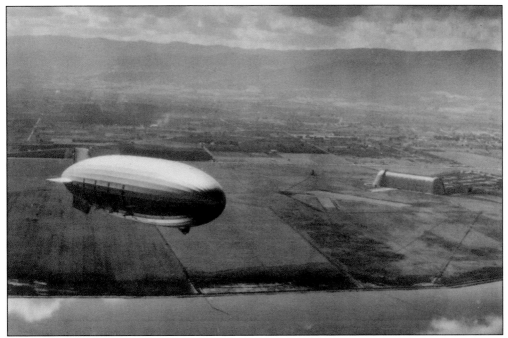

The photograph above is of the USS *Macon* patrolling over Hangar One. Between the runways and the east (left) side of the hangar was all open fields. Highway 101 is clearly visible adjacent to the field, with Mountain View, Sunnyvale, and the coastal range in the background. The photograph below is a fine view of Hangar One and the entire airfield. To the right, between Hangar One and the highway, the mooring mast and landing area for the dirigibles is clearly visible. (Both courtesy of Navy Historical Center.)

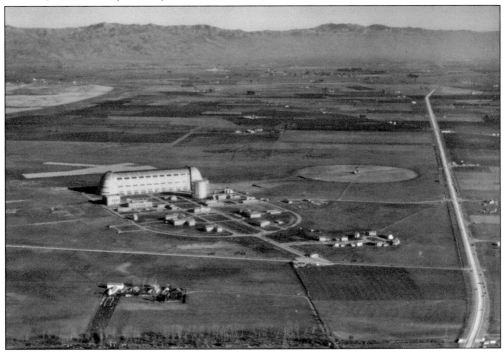

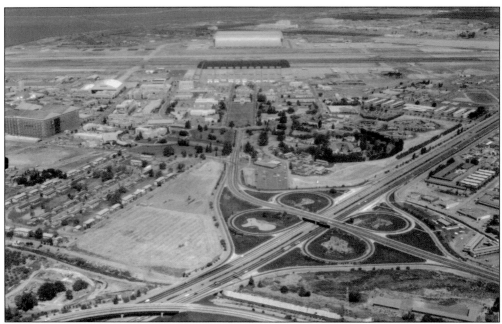

Above is a c. 1970 aerial view of Moffett Air Station and NASA's Ames Research Center. The left two spaghetti junctions from Moffett Boulevard and Highway 101 have since been removed. The base today is cluttered with many newer buildings. In 2008, volunteers from this project flew over the base and took a new look. At present, there are no definite plans for Hangar One. The cost of cleaning up toxic contamination and future uses for Moffett are still being debated. Many proposals have been suggested. (Above, courtesy of Santa Clara County Archive; below, courtesy of Carmen D'Agostino and Jack Friedman.)

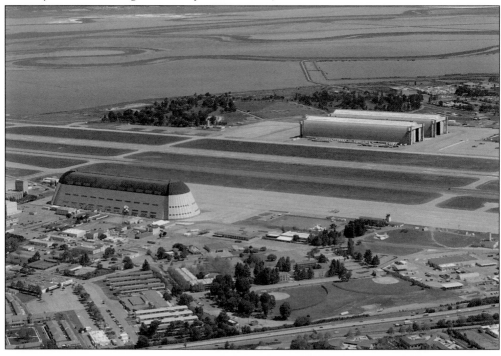

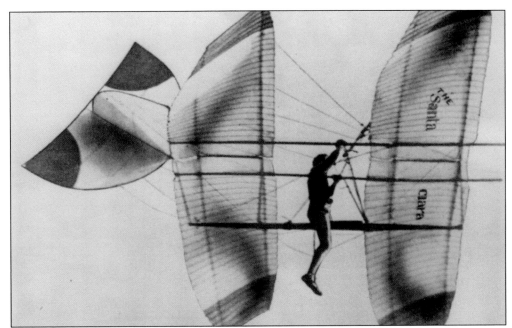

Aeronautics in Silicon Valley came a long way. Prof. John Montgomery of Santa Clara College started experimenting with gliders. He came up with a fixed-wing design with ailerons for stability and built a water tank to study air circulation. In 1894, Montgomery designed a 24-foot tandem-wing glider and recruited a parachutist to fly the "Santa Clara," which crashed in 1905. In 1911, Montgomery himself flew the "Evergreen," a new design that landed upside down in the east foothills by a park (the present-day site of Evergreen College, which was named after him). Montgomery's work and patents preceded the Wright brothers' by 20 years. The lower image shows navy fighters flying over Moffett Field in a 1960s photograph. (Above, courtesy of San José Public Library; below, courtesy of Navy Historical Center.)

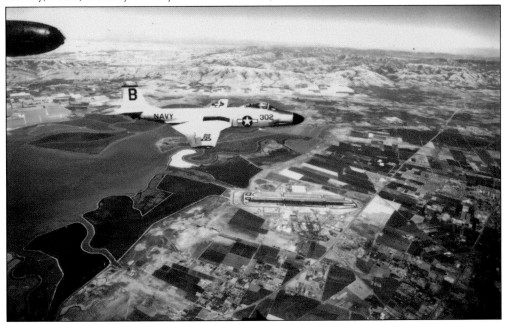

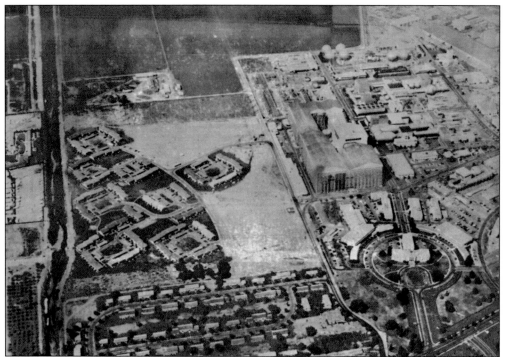

The photograph above, taken around 1975, is of the Ames facility located west of Moffett Field. It was founded in 1939 as an aeronautics research center. In 1958, it became a NASA center. Many jet airplane and spacecraft concepts were developed and tested here. With a $3 billion annual budget and over 2,300 researchers, Ames has played a crucial role in all space missions. Today it is engaged in the development of supercomputing, networking, space biology, and intelligent systems projects. The photograph below shows an air intake on one of the Ames subsonic speed wind tunnels. (Both courtesy of Santa Clara County Archive.)

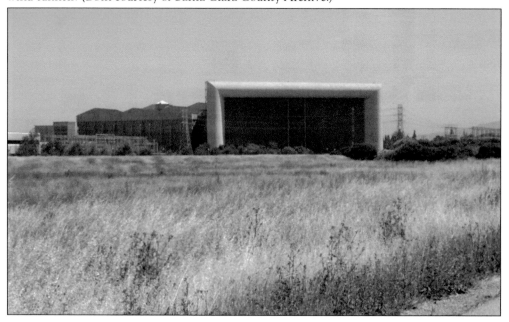

The photograph above shows the results of negligence in a corporate landscape. The company that developed supercomputers to animate the dinosaurs for the 1993 *Jurassic Park* movie has since diminished like the creatures it animated. Silicon Valley innovators and business owners believe in the future and accept the roller coaster business cycle, along with potential rewards and risks. The company that once occupied this building eventually filed for bankruptcy and sold all of its assets. Just a few years later, an Internet-based company took over the same deserted campus, making it one of the most successful companies in the early 21st century. That company had a market capitalization of over $121 billion in October 2008, but in a matter of days, the national economy took its toll. In good times and sometimes bad, Silicon Valley is a dynamic place. Ideas and innovations produced here impact all of human civilization.

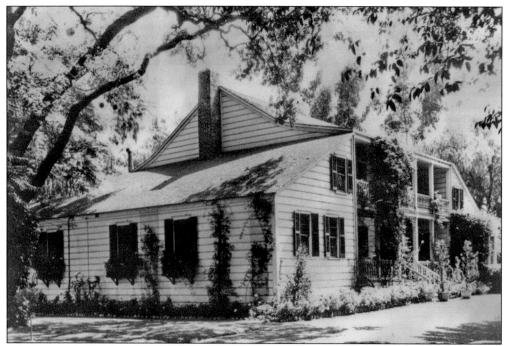

The site currently occupied by much of downtown Sunnyvale is on land originally owned by Martin Murphy Jr. He paid about $3 per acre of land. His 4,800-acre ranch extended from present-day Mountain View to Sunnyvale. The original home, shown here, was burned down in 1961. The second photograph is a replica of the original Murphy house in the Heritage Park Museum and allows the Sunnyvale Historical Society to relate how this prominent family contributed to Silicon Valley. Marie Boyd, a local resident and volunteer, poses in front.

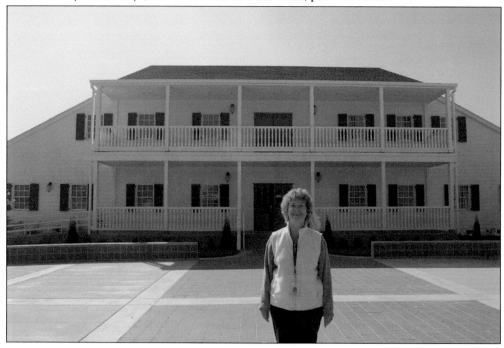

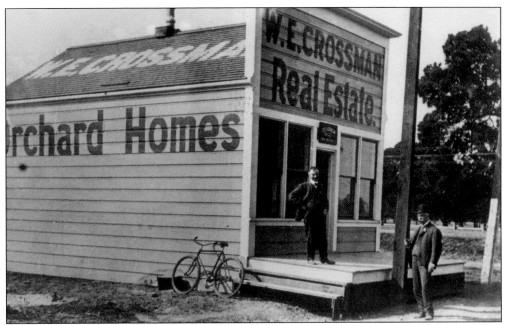

Patrick Murphy, son of Martin, lost money in gambling. He had to sell real properties to pay debts. Pictured above is Walter Crossman, a realtor who bought 200 acres of land from Patrick in 1897. Crossman advertised the area as Encinal, later as Sunnyvale, to attract customers. Later Grossman renamed it City of Destiny. Shown below is a 1940 aerial photograph of Sunnyvale looking toward Santa Clara. Fremont High School is shown in the center with its football field at lower right. The school has not changed much in front. The city of Sunnyvale is in the upper middle portion, and Moffett Field can be seen in the upper left corner. (Both courtesy of Santa Clara County Archive.)

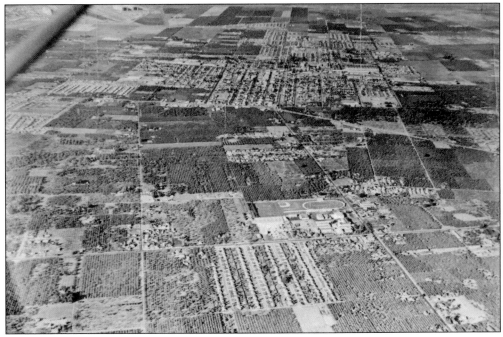

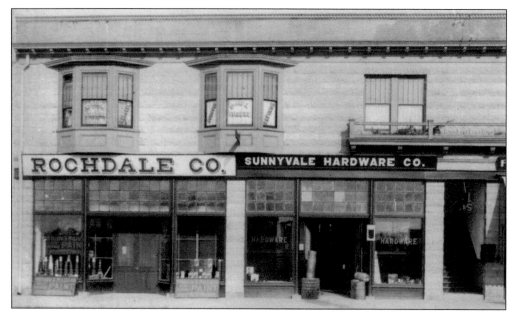

Many Sunnyvale businesses operated from Murphy Avenue date back as far as the early 1900s. One can find Sunnyvale Hardware and a doctor's office in the early-20th-century photograph above. Next is the same view from a 1906 Veteran's Day parade. Judging by the men's age and the Pres. Abraham Lincoln logo, most of the parade participants are likely to have served in the Civil War. Today the area has been renovated with many high-rise buildings. (Both courtesy of a private collection.)

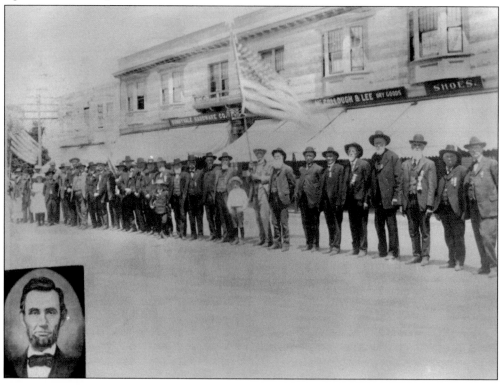

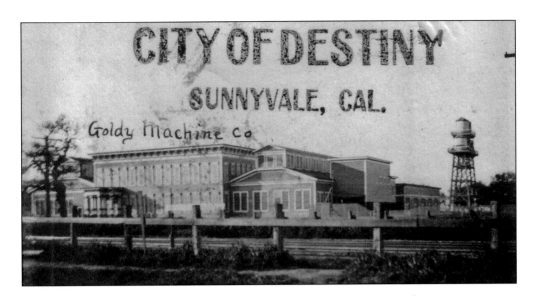

The U.S. Post Office rejected the proposed name of Encinal because it was already taken. The town shown here was called City of Destiny. To lure people from the foggy city of San Francisco, Sunnyvale was picked and incorporated in 1912. Many industries set up near Evelyn Avenue along the railroad tracks. One such firm was the Goldy Machine Company, located near Murphy Avenue and shown in this 1908 photograph. Jubilee Incubator Company, a poultry farm supply company, built their factory at Evelyn Avenue and Sunnyvale Road in 1907. The owner was Arthur W. Bessy. Many streets like Arques, Duane, Evelyn, Frances, Mary, Taaffe, and others were named after Murphy's children. (Both courtesy of a private collection.)

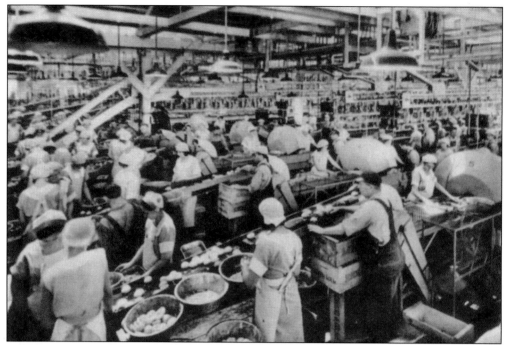

With access to the Southern Pacific Railroad, Sunnyvale soon became an ideal agricultural center. Before World War II, agriculture was the predominant industry in the valley, and there were many fruit packinghouses. One was Schuckl Cannery in Washington Park, shown in the 1930 photograph above. Another one was Libby, McNeil, and Libby, at California Street and Mathilda Avenue, for decades a business that was the center of food processing for the city. It employed thousands of workers and sometimes entire families worked there. (Above, courtesy of Sunnyvale Historical Society and Museum; below, courtesy of a private collection.)

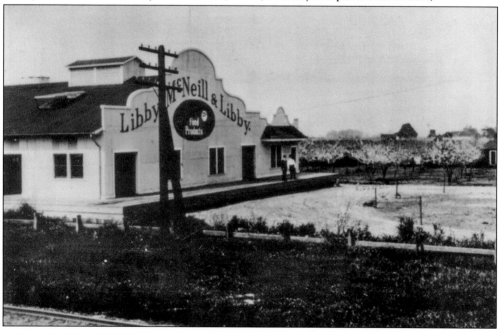

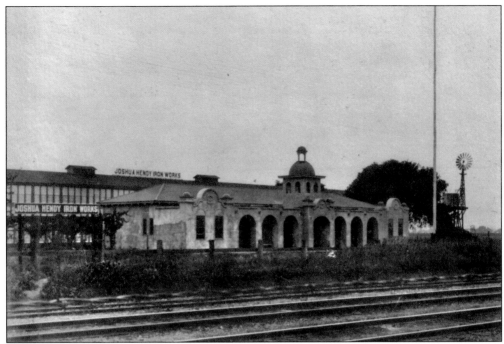

These two photographs show an exterior view of the Joshua Hendy Iron Works. The company built a giant factory in Sunnyvale at Fair Oaks Avenue and Hendy Avenue. It was a leader in western mining machinery. Much of the earth excavation equipment used in the construction of the Panama Canal was built by Hendy. It became an iron casting, machining, and assembly factory and could cast up to 30 tons of iron a day. The photograph below shows what it looks like in 2009. Across the train tracks are new housing developments showing the contrast of old and new.

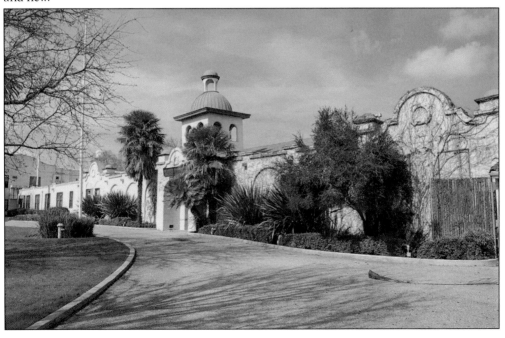

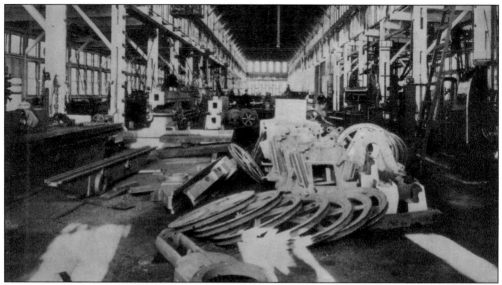

The photograph above shows the interior of the Hendy plant. It started manufacturing marine engines. Early engines could weigh as much as 137 tons and stood 25 feet tall. Hendy engines soon became better and faster to build. By 1941, the Hendy plant was in full operation to support the war. Many innovative methods were developed to make ship engines more efficient. The company boasted an employment of 11,500 during its peak. Just about everyone in town at the time worked for Joshua Hendy Iron Works. The image below shows the 1945 celebration of a milestone achievement at Hendy. A total of 754 liberty ships were launched, mostly from Oakland. (Both courtesy of Santa Clara County Archive.)

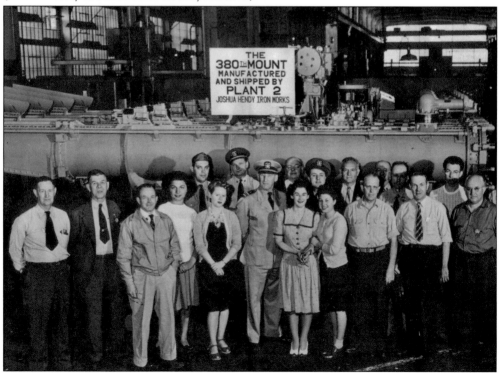

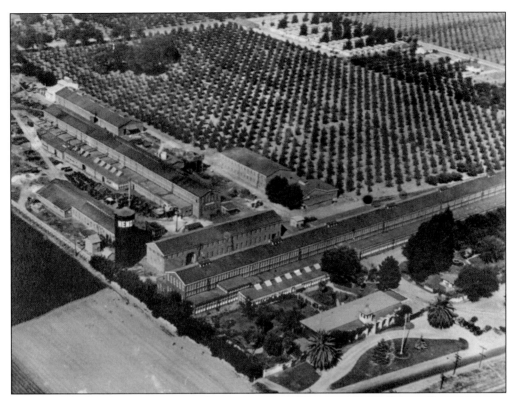

In spite of the heavy concentration of manufacturing, many buildings are still surrounded by fruit trees, as shown in the undated photograph above. By 1945, Joshua Hendy made more propulsion equipment than any company in the United States. The company was later sold to Westinghouse and continued to build nuclear submarine equipment and nuclear power plant components. The largest piece of equipment ever built was a 400,000-horsepower compressor for the U.S. Air Force with a shaft 500 feet long. A 1947 advertisement is shown at right promoting the company and area. Since 1996, Northrop-Grumman Marine Systems took over and now has 1,100 employees in the area. (Both courtesy of a private collection.)

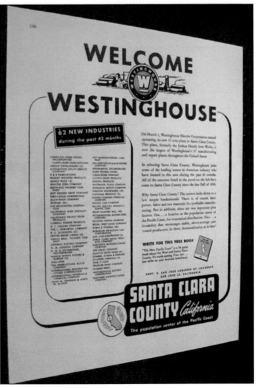

Sunnyvale is a culturally diverse city. This 2008 photograph shows the front of C. J. Olson's cherry store. The Olson family deeded a cherry farm to the City of Sunnyvale not long ago. Their old farm today has a strip mall behind it. Carl and Hanna Olson came to the area from Sweden in 1899 and have been selling fruit since 1933. Their children, Charles and Rose, and the family grew fruit and had up to 100 acres of orchards. They are also known for the preservation of their agricultural heritage. Deborah Olson runs a fruit business at 348 West El Camino Real, a block from Murphy Avenue. The second photograph shows C. J. Olson Cherries fruit stand with the owner, Deborah, posing in front. The store exhibits pictures of celebrities who have visited and tasted their delicious cherries.

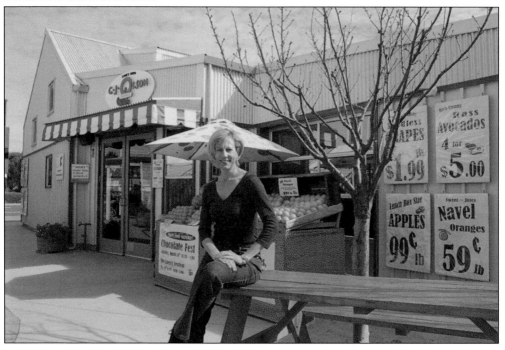

The photograph at right, taken around 1918, is of Paul Mariani Sr. and his family, who came from present-day Croatia. Paul Mariani worked in San Francisco and rode his bicycle on the weekends to Cupertino to date Victoria, who later became his wife. Through dedication and hard work, they had a successful fruit packing company near Apple Inc. headquarters. The company strives to make its product better through innovations. Because of the demise of local orchard land, the company has relocated to Vacaville. Today it sells over 125 million pounds of dried fruits. The image below is a c. 1941 photograph of C. J. Olson (right) and Mariani (left) with an agriculture official (center) at Olson's orchard near Mathilda Avenue and El Camino Real. Like the Marianis, the Olsons are also a fourth-generation family. (Both courtesy of Yvonne Jacobson and Deborah Olson.)

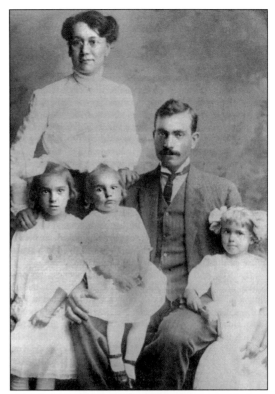

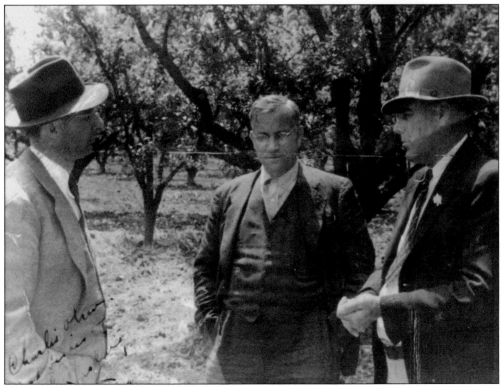

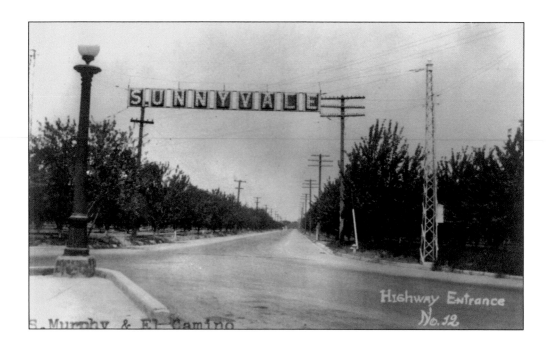

The photograph above, taken in 1921, shows an illuminated sign on South Murphy Avenue and El Camino Real welcoming people to Sunnyvale. Sunnyvale became incorporated in 1921 after it was renamed to attract Bay Area residents who wanted to get away from coastal fog. Names used earlier, such as Encina or Murphy, had been rejected by the postal service. The photograph below depicts the same corner 39 years later. In 1960, the left side of the corner became a strip mall. A gate reading "Sunnyvale Shopping Center 3 blk." replaced the original illuminated sign.

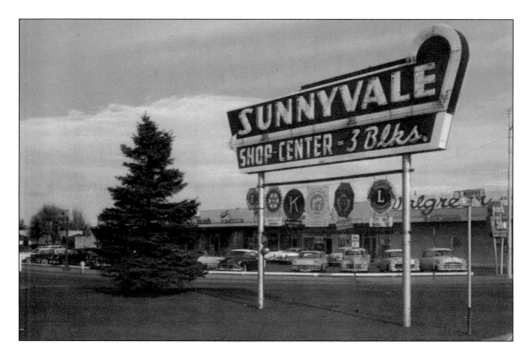

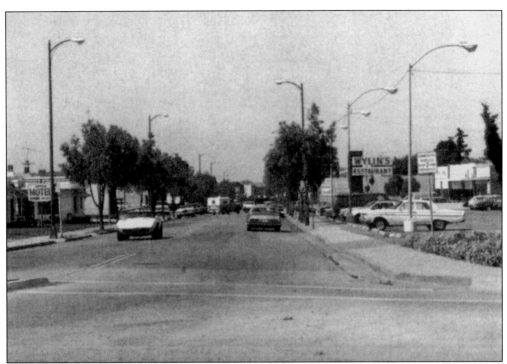

Another 24 years went by, and in 1984, a restaurant and a motel replaced the Walgreen's in the previous picture. The drugstore moved a few blocks away. The tree and the gate are now gone. Twenty-four years beyond that, in 2008, the motel still stands here with mature trees. The older vintage trees replaced the 1921 orchard. Yvonne Olson-Jacobson, a well-respected historian, vividly recalls growing up in the area.

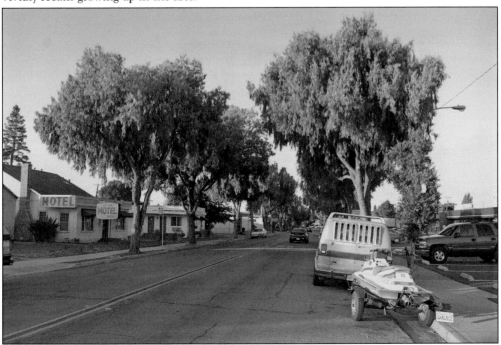

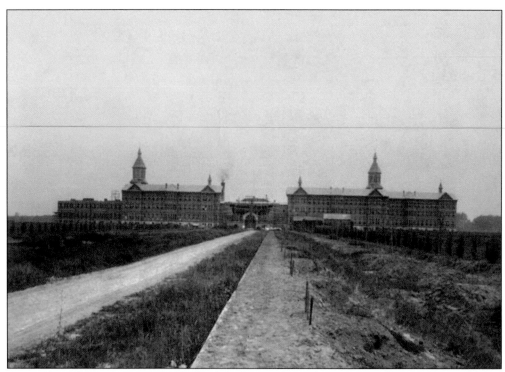

Agnew Development Center, a medical facility with emphasis on psychiatric treatment and rehabilitation, was established by the California legislature in 1885 on the land of Agnew's Village. The photograph above, taken in 1887, shows the original building with an incomplete clock tower in the middle. The 1888 photograph below shows the complex near completion. The buildings are formally placed within a landscaped garden with palms, pepper trees, and lawns. The Agnew Station, built nearby in 1878, is the only train depot remaining from the Southern Pacific narrow-gauge line today. (Both courtesy of a private collection.)

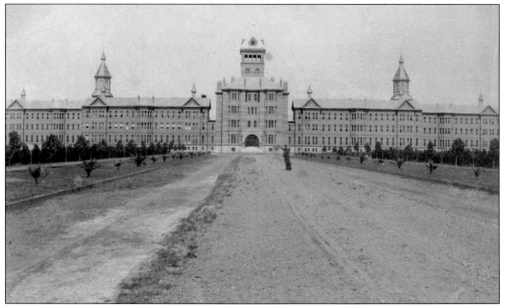

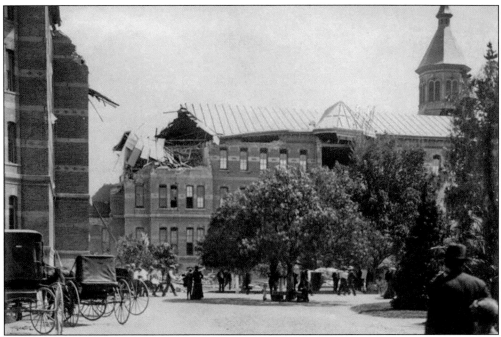

In 1906, the facility was heavily damaged by the earthquake. It was felt for a minute on the Moment Magnitude Scale (MMS) as a 9, meaning very strong (equivalent 7.9 on the Richter scale). Many multi-storied buildings at Agnew, made of mason, crumbled and took the lives of 125 patients and staff. The 1989 Loma Prieta earthquake, which lasted only 15 seconds at MMS scale 7, resulted in only light damage, as structures were upgraded.

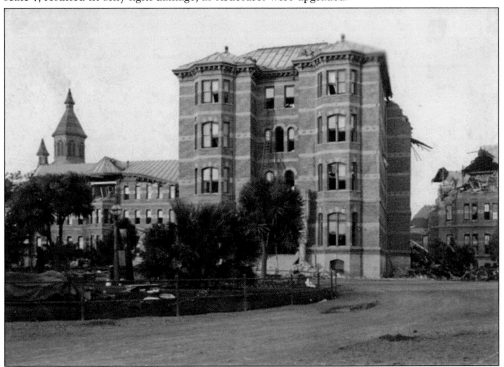

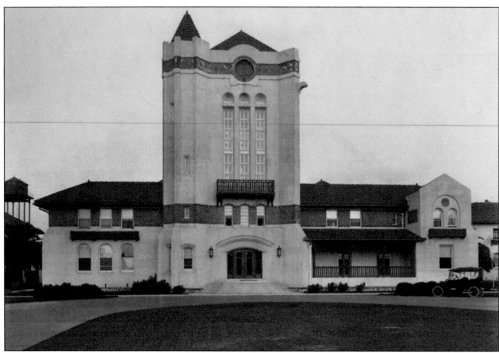

The former medical-treatment building was rebuilt after the 1906 earthquake as a clock tower. Agnew State Mental Hospital was one of the most renowned clinics for modern treatment of mentally challenged patients in the 1960s. After the discontinuation of state funding instigated by then-governor Ronald Reagan, the institution fell into disuse. In 1996, Sun Microsystems purchased the remaining 83 acres. Only four buildings remained, and a total of 44 had been demolished. The photograph below was taken on September 11, 2008, with flags flying at half-mast.

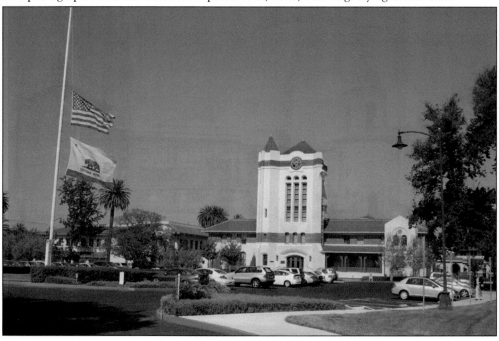

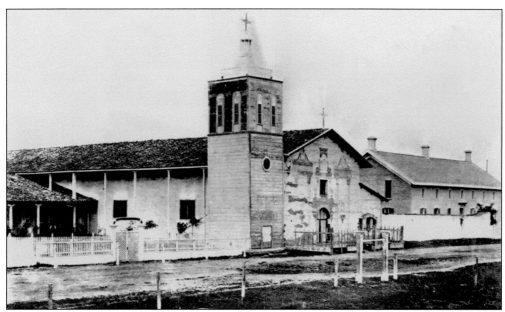

Built in 1825 along El Camino Real, Santa Clara Asis was the eighth Spanish mission built in California. The church was supported by a thick adobe wall, which stood 100 feet long, 22 feet wide, and 20 feet tall. In 1851, the Franciscan bishop recognized the need for more schools and ordered the establishment of Santa Clara College, the first college in the state. Shown above in 1861, a wooden facade was added with a bell tower, following the Jesuit style of cathedral architecture. Photographs from the 1890s reveal that a wrought-iron fence was erected on the west side of Alviso Street. El Portal was actually south of today's Palm Drive facing today's St. Joseph Hall. A century ago, it was a dirt road and had an open field extending to El Camino Real.

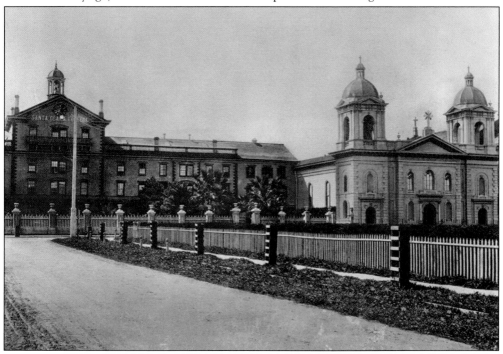

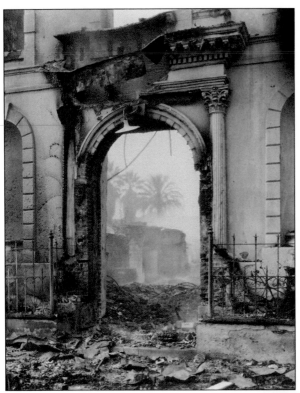

A fire broke out in 1926, and a chapel was rebuilt with items rescued from the fire. It continues today to serve as the community chapel for masses, baptisms, weddings, and funerals. The Mission Church is still in use and open to the public. The building on the left is St. Joseph's Hall (not shown in the 2001 photograph below), rebuilt in 1911 using steel-reinforced concrete to make the building capable of withstanding future earthquakes. The retrofitted mission revival–style building is today the dominant feature on campus.

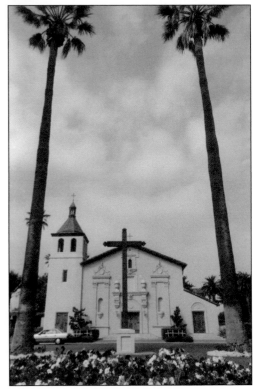

The Mission Gardens, a gorgeous site for public and private gatherings, is situated behind the church. It has a Sacred Heart statue, wisteria vines, grapes, and cork trees whose bark is used for wine bottling. Ricard Observatory is named after Prof. Jerome Ricard, a Jesuit priest who was the pioneer on sunspot theory (shown here facing left along with his observatory). His weather-forecasting theory won him the title "Padre of the Rains" in the early 1900s. Sing Kee, a local Chinese laundry businessman on Franklin Street, used frogs for short-term weather and earthquake forecast. Both methods worked to some extent.

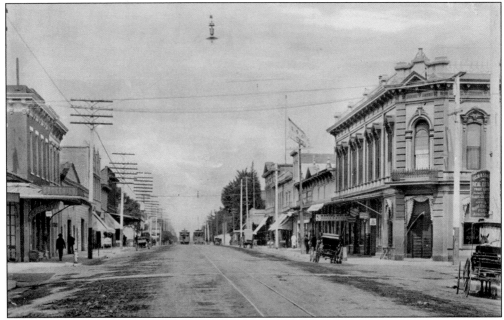

El Camino Real was the original road connecting Santa Clara to San Francisco. Twenty years ago, taking a drive from Santa Clara to San José along this road gave one a feel for what the route was originally like. According to Santa Clara City librarian Mary Hanel, this photograph was probably taken in 1907 at the intersection of Washington Street and El Camino Real. IOOF No. 52 (Independent Order of Odd Fellows) a popular fraternal organization, stayed at that location for 82 years. Today there is little, if anything, remaining of this neighborhood. The motel is approximately where the IOOF building stood. The bank building is where the used car lot stands today.

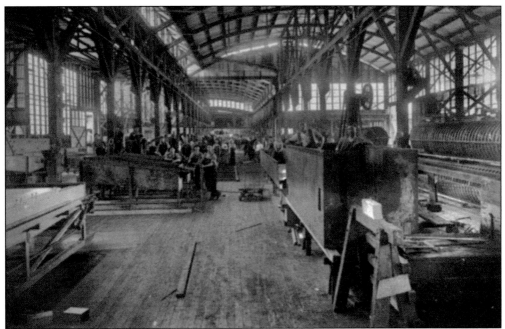

The Food Machinery Corporation (FMC) originally made equipment for use in the food production industry, shown in the 1920 photograph above. It was located on Coleman Avenue adjacent to Minetta International Airport in San José. In 1960, it became a manufacturer for military track vehicles and had a test-driving ground. Over 14,000 M113 fighting vehicles have shipped to 50 friendly countries. The M113 was a light-armored troop carrier taking two drivers and transporting up to 11 soldiers. It was used extensively during the Vietnam conflict. Until it was closed in the 1980s, FMC produced thousands of the vehicles for the U.S. military. (Both courtesy of U.S. Army.)

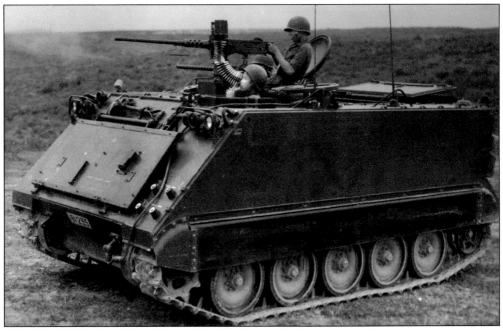

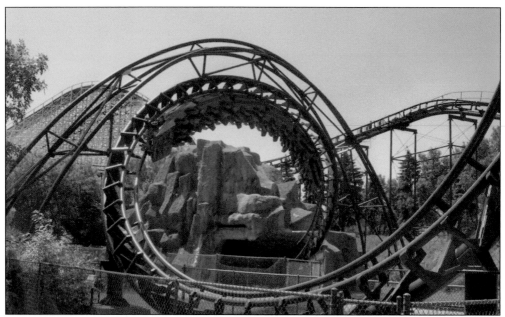

Arrow Dynamics, founded by Karl Bacon and Ed Morgan and located at 243 Moffett Boulevard in Mountain View, designed and manufactured many of the rides seen in the amusement park. In 1976, the Marriott Corporation opened Santa Clara Great America Park, which set examples for future Marriott parks. It offers exciting rides like this 1987 Revolution. The carousal was a great merry-go-round ride that appears in several Hollywood movies. Arrow Dynamics also built the Matterhorn Bobsleds, the "It's a small world" ride, Dumbo elephants, and corkscrew roller coaster designs. The Demon, seen in the photograph above, has the corkscrew feature enjoyed by many park visitors. The Revolution, shown below, is another thrilling ride.

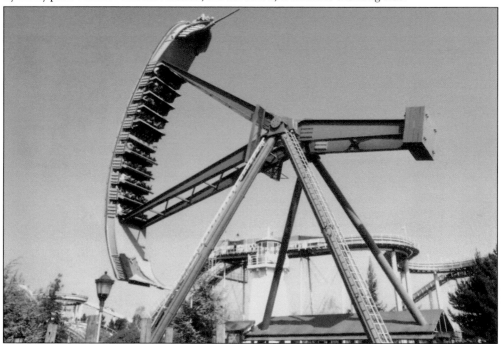

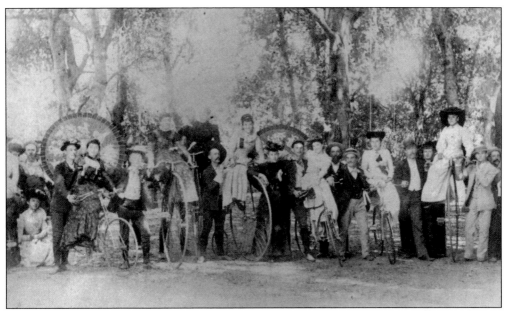

The name Cupertino can be found on De Anza's expedition survey map as "Arroyo de San Guiseppe Cupertino." The spot where the De Anza party camped is close to Monte Vista High School. In 1844, Capt. Elisa Stephens purchased 160 acres of land and grew blackberries on the west side of the farm near a geological dip. He was soon dissolute by the early grant, where he had to compensate El Quito owners over his patent, so he moved on. Here is a photograph of late-19th-century adventuresome young cyclists posing on Stephens's old Black Berry Farm, which is off present-day Stevens Creek Boulevard. Today the farm is run by the City of Santa Clara with a park and golf course. Note the street name, reservoir, and creek have been misspelled as Stevens. (Both courtesy of California Historical Center.)

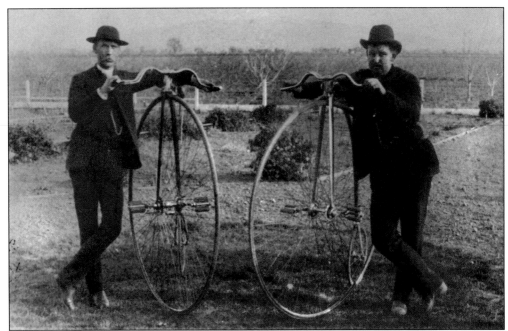

The Stelling family acquired a farm from Elisa Stephens, whom the street is named after. Shown here, the Stelling brothers stand in front of their two-wheel velocipedes, also known as the "boneshaker," used during the Victorian era. Their neighbor, Alexander Montgomery, had a contractor build him the San José Home Union General Merchandise Store around 1892. Four years later, the name was changed to the Cupertino Store. The building served as the West Side Post Office, and Wells Fargo Express also had a stop here. Stevens Creek Road was paved around 1916. The store name change was made by the new owner, Arch Wilson. Wilson was the postmaster and also managed the store for 42 years, retiring in 1946. (Both courtesy of California Historical Center.)

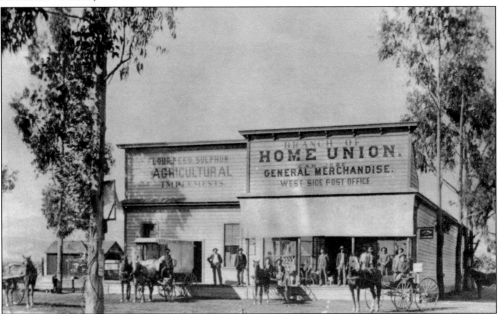

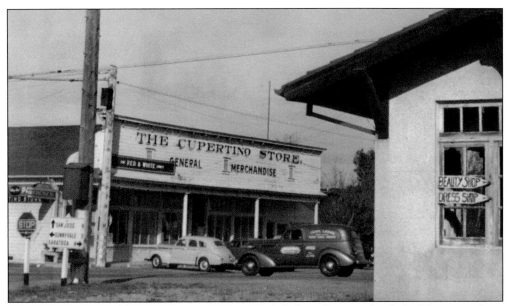

Convenient green public transportation was provided along Stevens Creek for 24 years with an electric trolley. The trolley took passengers from Palo Alto (west), Los Gatos–Saratoga (south), and San José to Alum Rock (east) through downtown San José hub. In 1935, GM stripped all rails to get Americans to drive gasoline-powered automobiles. The rails were sold as scrap metal to Imperial Japan and ended up as part of the war machine to terrorize Japan's neighbors. The 1950 photograph above depicts the Cupertino Store when it was in continuous operation for 58 years. Another half-century went by, and the old general store became a Chinese-American bank on a busy street corner. Few people realize William T. Baer's old blacksmith shop and first garage stood at today's gas station across the street.

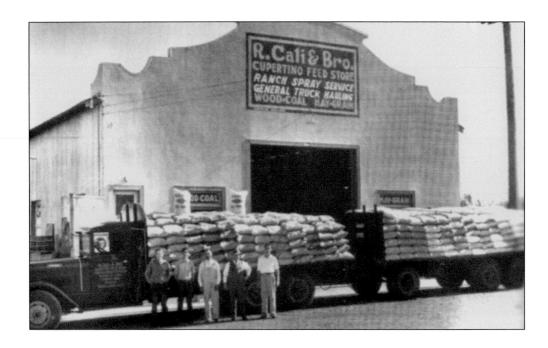

The Cali family owned the land on the southeast corner of the crossroads in 1925. The brothers were in grain, hay, and transportation businesses across the state. After the 1940s, they became developers on commercial properties. Their feed store was razed in 1988, and the feed business was later sold to An-Jan Feed and Pet Supply. The area later became Cali Plaza.

The photograph above shows the mural painting in front of Armadillo-Wileys restaurant. It depicts the bygone businesses of Cali, Mariani, Nursery, and Charles Baer's former garage. A smiling worker from the restaurant poses in the photograph. Symantec computer, a major local employer dedicated to eradicating computer viruses, is located next door. The Sutherland vineyard across the street is now occupied by the Cypress Hotel and a high rise piazza-like condominium named Mentebello.

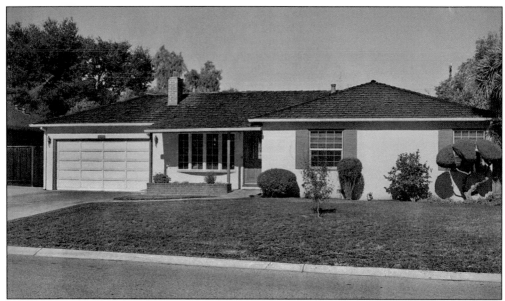

In 1976, two young men, Steve Jobs and Steve Wozniak, met at Stanford Linear Accelerator Center's computer brewer club and decided to launch a personal computer business in Jobs's parents' garage, shown here. The name Apple was adopted because Jobs was a vegetarian. The name was also deemed less intimidating, as computers were not machines everyone could easily master. Much of the modern development in Cupertino was financed by the success of Apple. *Fortune* magazine named Apple the most admired company in the United States in 2008. Apple Inc. is headquartered at 1 Infinite Loop in Cupertino across from the old Mariani fruit packinghouse. On August 13, 2008, Apple's market capitalization surpassed Google, a Mountain View–based Internet company.

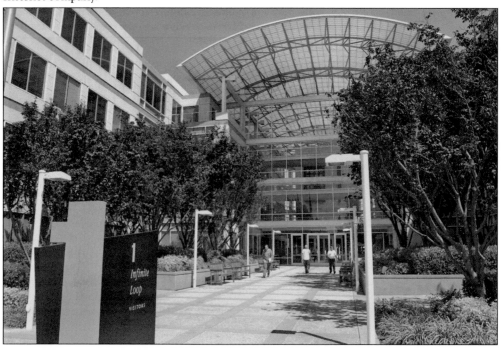

The photograph above shows an example of an Eichler home in Rancho Riconada. Joseph Eichler (1900–1974) was a prominent builder from the Bay Area. After the Second World War, there was a need for modern California homes. Approximately 11,000 Eichler homes were built in today's west Silicon Valley, San Mateo, and the East Bay. They are characterized by an open floor plan (to save wall materials) and more lighting, in a style credited to Mies van der Rohe. Some homes were built with an atrium. Eichler's motto was "bring outside [light] in." Homes were constructed with large glass windows, slab floors, sloped roofs, and a second bathroom not found in earlier home designs. To sell his homes in volume, he sold to any race who could afford them. The photograph below shows a front view of a well-preserved home with the unique indoor atrium.

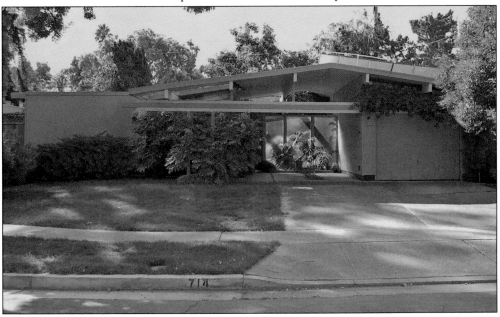

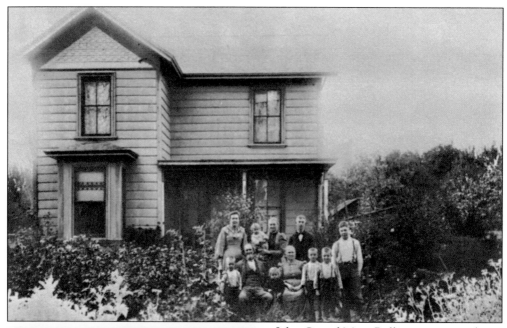

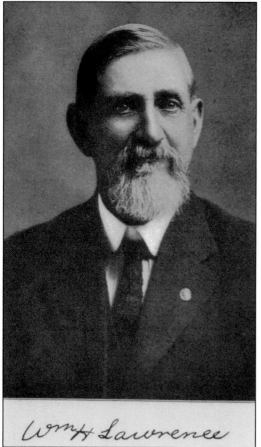

Wm H Lawrence

John C. and Mary Bollinger came to the area after 1872 from Bollinger County in southeast Missouri and purchased a farm. The 1887 map shows that Bollinger owned a 280-acre farm on the south side of Cottle Road (called Bollinger Road today). The Bollingers have four children: Jim, Rachel, Clara, and Evelin. Together John and Mary have 67 great-grandchildren. Bollinger was neighbor to C. Tantau. The Bollingers had a Victorian house and grew grapes, as shown in this late-19th-century photograph.

Albert C. Lawrence (1810–1886) came from New England and bought a 160-acre ranch. When the Southern Pacific came, he donated a right-of-way land parcel, adding Lawrence Station to his ranch. He became the agent at that station until his death. Today Lawrence Expressway is named after this pioneer. This is a picture of his son, William H. Lawrence, taken in 1910.

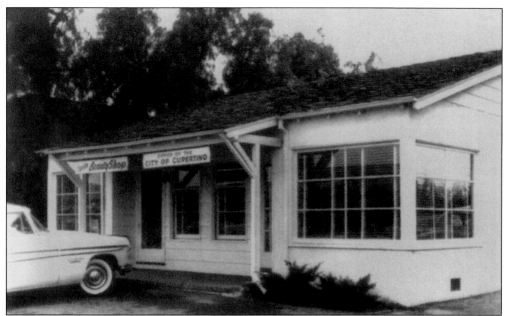

Cupertino was a rural village and was not incorporated until 1955. As such, it used to operate on a small scale, sharing the old city hall with a beauty shop at 10321 Saratoga-Sunnyvale Road. The Vallco Business and Industrial Park (now Cupertino Village) flourished in the early 1960s. Today Cupertino houses some of the largest high-technology firms in the world, including but not limited to Apple Inc., Symantec, and HP. Highly skilled and educated workers prefer to work and live there. Now a city of 52,000 residents, it is known for having excellent schools and visions. Now-defunct Mervyn's and other stores occupied the old Crossroads. Few people realize that this was where the Eastside's first post office, Baer's blacksmith shop, and general store once stood. Today the modern city center is planning to become a leading-edge city with visions for innovative city planning.

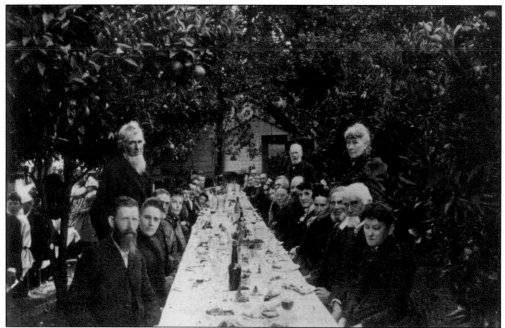

James P. Bubb grew grapevines and crops on his farm across from his neighbors, the McClellans. Bubb's winery was often mentioned in *Pacific Wine and Spirit Review* and the old *San José Mercury News*. Above is an undated 19th-century photograph of the Bubb family and neighbors gathering. It was noted that in the spring there were seas of blooming flowers as far as eyes could see. It was the most beautiful scene of the Valley of the Heart's Delight. Below, this 1880s photograph shows the area east of Stevens Creek and Sunnyvale-Saratoga Road (now South De Anza Boulevard). (Both courtesy of San José Historical Society.)

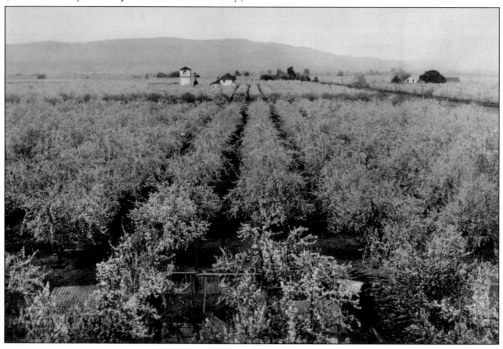

Four

THE SILICON CAPITAL

San José, the 11th largest U.S. city, is the corporate, financial, and cultural center of Silicon Valley and a major exporter of high-tech products. Every year, over a million visitors come to convene and do business. The city's roots can be traced to the days of the Spanish mission. San José was the state capital in 1849. By 1950, it had 95,000 residents. During the 1960s, rapid development in housing precipitated the annexation of neighborhoods that were mostly rural. For the last 20 years, San José has reinvested in redevelopment of the downtown to rejuvenate business. It has deployed a light-rail system, convention center, and technology museum. The city is also home to a National Hockey League team, the Sharks. Today the bulk of high-tech business is concentrated north of the International Airport. Encircling this area are tracts of homes, strip malls, and more new high-tech parks. A number of historical homes, however, are well preserved. Silicon Valley has the talents and resources to generate new technology from its base. (Courtesy of San José Historical Society.)

SAN JOSE
City with a Past

St. James Square dates back to 1848, the beginning of San José's era as the state capital. Beginning with the construction of the Trinity Episcopal Church, the square was the favored site of many public buildings, including an old courthouse and a club. Separated from the downtown's modern commercial district, the St. James Square has been preserved, and it remains one of the few areas maintaining San José historic legacy. The nine surrounding buildings all have historical significance and have since been listed on the National Register of Historic Places. Much old history showed local life centered on the park. (Both courtesy of San José Historical Museum.)

The picture card above depicts the Bank of Italy along First and Santa Clara Streets around the 1890s. Downtown San José was full of life, and the interurban trolleys (shown here) had been operating for some time. The route starts in Alum Rock, goes through San Carlos Street, and connects to the west through Stevens Creek Road. The photograph below was taken in the 1930s and also shows the Bank of Italy at the corner of First and Santa Clara Streets. A. P. Giannini, a native of San José, started a banking business by lending money on that street after the disastrous 1906 earthquake. By taking care of all customers properly, it grew to become one of the largest banks in the country, Bank of America. The Bank of America building had two major renovations with more top floors added.

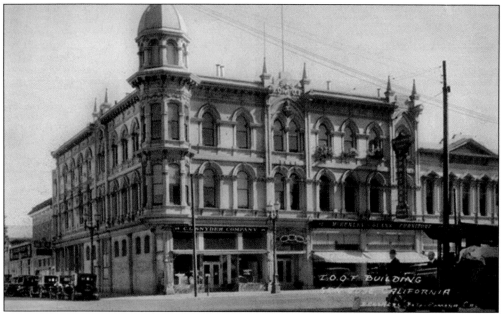

The Independent Order of the Odd Fellows (IOOF) building (figure 162, upper right) was designed by Jacob and Lenzen. To become a member of the IOOF, one has to be of good health validated by a medical doctor and have sponsors. Once initiated, one first had to learn the mystic signs and be able to communicate with another member using them. The photograph below shows a c. 1919 IOOF society parade along Santa Clara Street. The left side of the photograph shows the office pictured earlier (page 74) with an extra floor. It was a popular brotherhood organization. The fraternal order is still around but not as large as in the early 20th century.

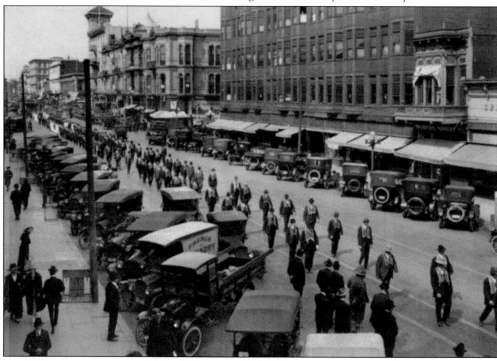

Alexander J. Hart (born 1869) was an astute businessman. He learned the business from his father as a youngster. By 1912, his small department store business had grown to 150 employees with 50,000 square feet of retail space and 35 departments. Hart's filled 32 pages with advertisements in the *San José Mercury News*. In 1933, Alexander Hart's son Brooke was kidnapped and murdered. The angry mob took the kidnappers from the jail and lynched them in St. James Park. The lynching drew national attention. Due to competition with chain stores and suburban malls, the Hart, Hale Brothers, and Woolworth stores were all closed by the mid-1970s.

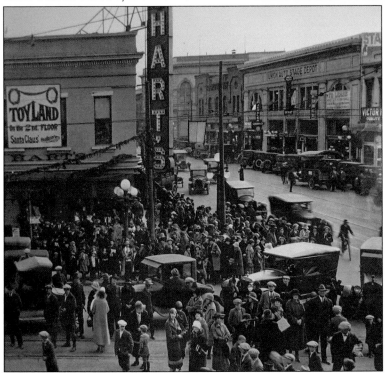

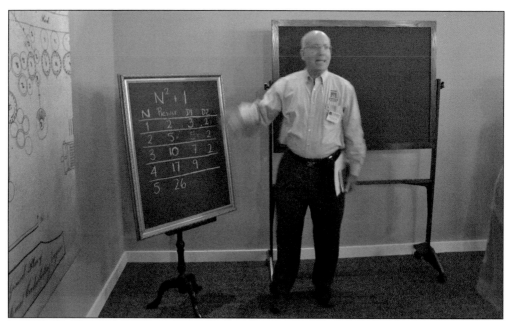

In 1822, Charles Babbage was frustrated by human error in the compiling of mathematical tables. He was determined to design a machine to correct this problem. Babbage's son Henry finally completed his father's wish by building a mechanical computer using parts found in his father's old laboratory. The computer's architecture is similar to that of a modern computer. The data and program memory were separated, operation was instruction based, the control unit could make conditional jumps, and the machine had a separate input/output unit. Algorithms were worked out to allow mechanical parts to compute. Here at the Computer Museum in Mountain View, a staff member demonstrates how the Babbage computer works.

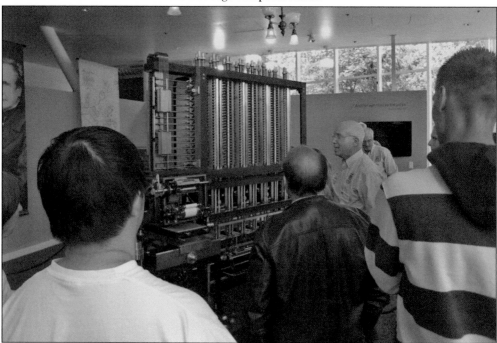

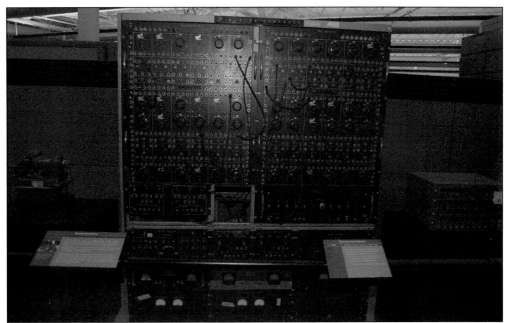

Shown above is a 1959 GPS analog computer. Mechanical and electrical mathematical expressions are analogous, and one can simulate one with the other. These are known as mechanical-electrical analogies. From the early 20th century, many tasks were done with mechanical devices. Electric analog computers using vacuum tubes, resistors, capacitors, and inductance were essential before the commercialization of microprocessors. They were used especially in military applications. For example, the Mark 1 computer built by Ford Instruments in Palo Alto for naval guns weighed as much as 3,200 pounds. Linear and non-linear systems alike can be simulated with sophisticated integrators, potentiometers, and up to several state variables. The author's father used the Pickett slide rule below to design some huge dams and used an abacus to calculate cost and materials. (Both courtesy of Computer Museum.)

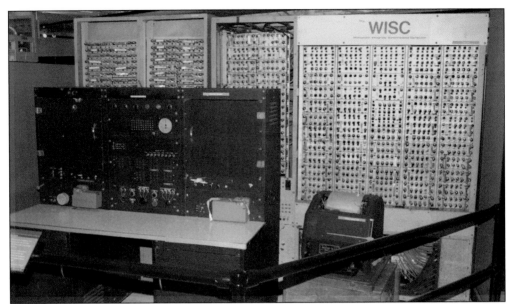

The Amdahl Corporation was originally a mainframe company in Sunnyvale on Argus Avenue. Founder Gene Amdahl developed a digital computer at the University of Wisconsin as a student. It was used to train graduate students in the emerging field of computing. WISC (above) used paper tape and a teletypewriter. Its memory was a rotating magnetic drum. Amdahl became a computer chief architect at IBM. The lower photograph depicts what Amdahl built at IBM. The System/360 (1964–1977) was a digital computer family that made IBM the recognized acronym for computers at the time. S/360 was extremely successful in the market, allowing customers to purchase a smaller system with the understanding they would always be able to upgrade the system later. The design is considered by many to be one of the most successful computers in history, influencing later computer design. (Above, courtesy of Computer Museum; below, courtesy of Santa Clara County Archive.)

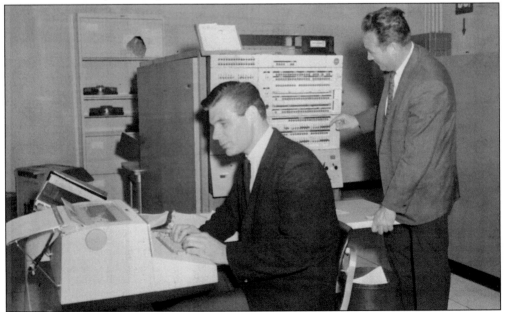

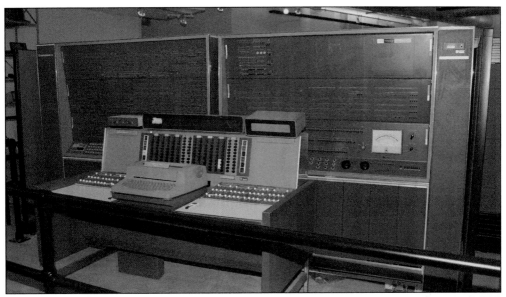

Lawrence Livermore Lab in 1955 requested a computer running 1–2 MIPS instructions (MIPS stands for million instructions per second, a measurement of processor speed). Gene Amdahl himself worked on the proposal. It did not meet the requirements. It selected another manufacturer instead. Amdahl was discouraged and resigned from IBM. The IBM 7030 was, however, the fastest computer from 1960 to 1964 and sold for $13.6 million in 1960. The photograph above shows a 7030, a dual-CPU system. Although it was not successful, it spawned many technologies. All later mainframe and small computers, including Intel Pentium and Power PC, used 7030 architecture. In the photograph below, the Electrodata system uses thousands of vacuum tubes. The company was acquired by Burrough and became Unisys. Unisys still has offices in Silicon Valley. (Both courtesy of Computer Museum.)

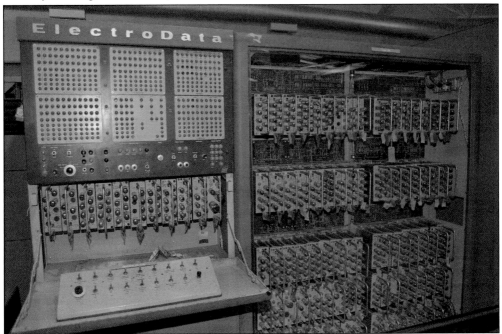

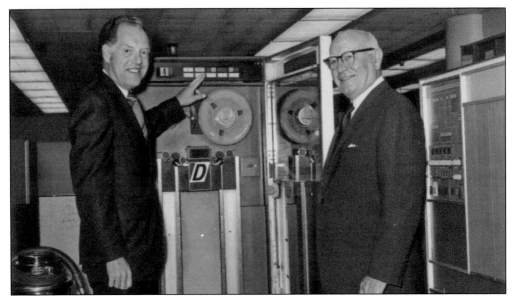

An IBM system S/360 once supported the entire Santa Clara County government with only 16 kilobytes of ram memory. The computing power on the earlier mainframe machines was limited. One had to run and stack batch jobs for processing. Key punch cards were supplied by the IBM plant in Campbell, California. Above in 1971, two officials, in front of a 3420 IBM tape drive, are shown at Santa Clara County Information Systems Department (ISD). These computers employed 10.5-inch tape reels that came in either seven or nine tracks and had up to 1.25 megabytes of storage. The photograph below is of a removable 14-inch Winchester (the IBM 3330) disk packs later used at ISD. The Winchester disk files, code named after Sara Winchester's house, were developed in San José and had a storage capacity of 200 megabytes. (Both courtesy of Santa Clara County Archive.)

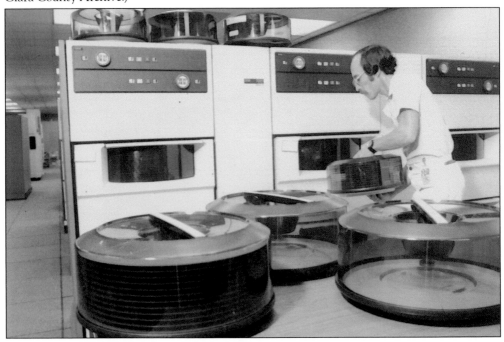

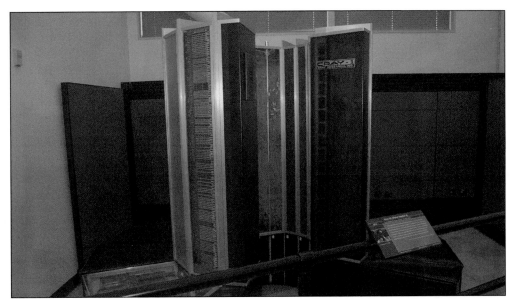

Some supercomputers were not developed locally but had a presence in Silicon Valley. The Cray-1, shown above, was used by government labs; it boasted a world-record speed of 160 megaflops of operations and had 8 megabytes of memory. The Cray-2 system appeared in 1985 (shown below), providing performance 12 times faster than the Cray-1. In 1993, the Cray-3 was developed using gallium arsenide (GaAs) to replace silicon, which had a processing speed limit of 244 megahertz. The Cray-3 provided tremendous computing power, used by local researchers. Some systems generated so much heat that the CPU had to be cooled in Fluorinent immersion. One type of computer technology used up to eight processors to increase computation speed. Cray Research Company encountered financial difficulties when Cray-4 (1-gigahertz speed) was developed. It was purchased in 1996 by Silicon Graphics (SGI), located in Mountain View. (Both courtesy of Computer Museum.)

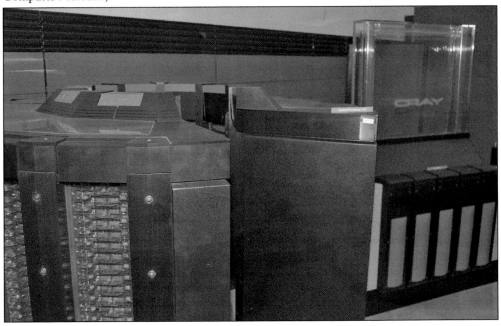

The photograph above is of the 1958 dedication of the IBM cafeteria and a halo sculpture. IBM launched a small computer-development office in 1952 in downtown San José. In 1955, the company purchased a 300-acre site in South San José. Several thousand IBM employees on one campus worked together. Local IBM had a significant impact on the growth of the Silicon Valley. The BART system, ATM machines, relational databases, laser printers, tape drives, and, notably, the invention of hard and floppy drives were all developed by IBM in South San José. The image below is a 1958 photograph of San José police chief and IBM CEO Thomas Watson with Soviet General Secretary Nikita Khrushchev, Andrei Gromyko, and the Russian foreign minister. Khrushchev came to visit the IBM plant; he boasted that Russia also made more Winchester hard drives but better "machines." The Soviet leader was also surprised to learn that Americans drove solo and thought that America would run out of gas someday. (Both courtesy of IBM.)

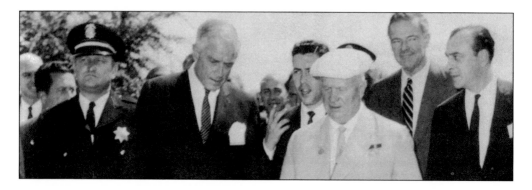

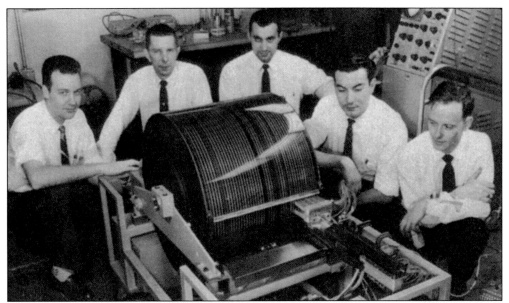

Silicon Valley always served as the leading research and development center for technology. This is a 1957 IBM Advanced Disk File team in South San José working on the earliest disk drives used on digital computers. Flying magnetic recording heads powered with compressed air were used to fly over rotating 2-foot diameter disks ganged together. This later became the 305 RAMAC. It was the last vacuum system designed, with over 1,000 systems shipped. They were manufactured in Building Five on a wooden floor. Product 305 had a storage capacity of 5 megabytes. In 1957, the monthly cost of renting the storage service provided by the 305 was $150 per megabyte. The product was replaced by more powerful drives in 1961. (Both courtesy of IBM.)

Above is Intel Building 1 in Santa Clara. The company was founded in 1968 with the mission to make semiconductors more practical. Its 8088 chip for the IBM PC changed the way people use computers. The silicon technology deposited metals to fabricate tiny transistors on a wafer to make chips. Today a dual-core Itanium 2 CPU contains approximately 1 billion transistors with 65-nanometer thin film technology. Initially, the wafer was only 2 inches in diameter and 45 microns in size. As the effort has grown to make transistors able both to run faster and be more affordable, the wafer size has grown to 12 inches while transistors have shrunk to 30 nanometers in thickness. The photograph below shows a Core 2 Mobile CPU using 45-nanometer thin transistors operating at 2.1 gigahertz. (Both courtesy of Intel.)

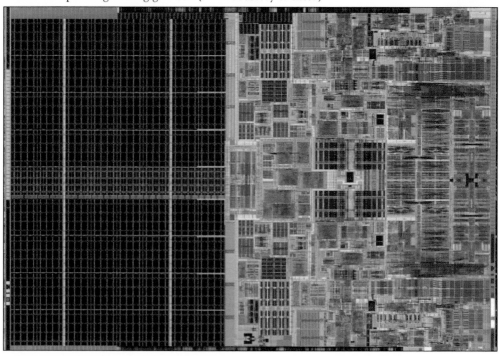

The photograph above shows a team of scientists at Intel proudly demonstrating an optical modulator on a silicon wafer transmitting data at 40 gigabytes per second. Scientists work hard to increase the data rate by researching ways to put photonic integrated circuits (IC) on silicon chips. IC technology and compact servers have changed the way data are being stored. The photograph below shows an IBM development team celebrating the shipment of refrigerator-sized hard drives with a storage capacity of 22.7 gigabytes in 1989. People now prefer pocket-sized hard drives and favor solid state devices. Silicon Valley has a cosmopolitan feel and for thousands of highly trained engineers is the dream location to work. (Above, courtesy of Intel; below, courtesy of a private collection.)

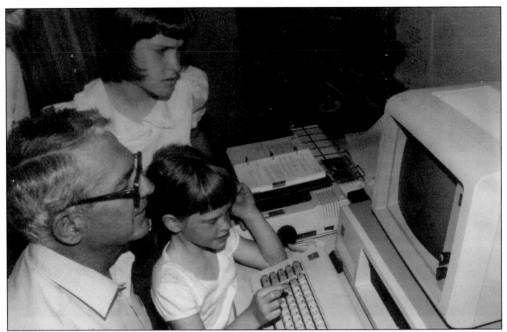

The picture above features children being trained to use the original PC around 1981. With Intel 8088 microprocessors, IBM introduced one of the first personal computers. Bill Gates was asked to provide an operating system (DOS). The original PC had 16 kilobytes of memory and came with either one or two floppy disk drives. Its entry-level cost was around $1,565. Twenty-eight years later, PCs used are much more powerful and have a smaller footprint. The affordability of PCs today allows children at very early ages to try out the 2nd Generation Classmate PC at the Intel Museum below. (Above, courtesy of San Martin Presbyterian Church; below, courtesy of Intel.)

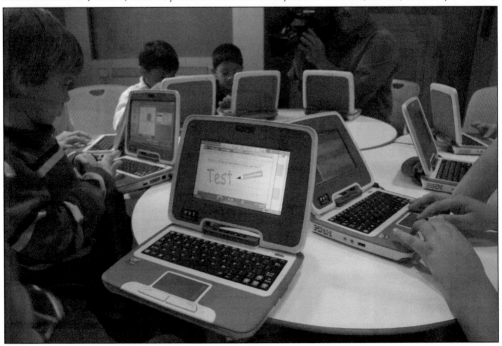

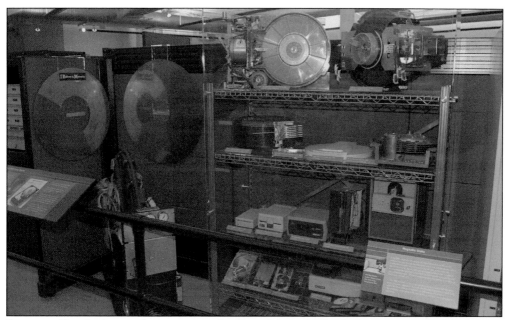

Because of local talent in data storage technology, Silicon Valley had many startups. Above is an assortment of disk drives used in various applications. In 2007, at the Computer Museum, a group of enthusiastic supporters fired up a 1957 vintage 305 RAMAC hard drive. Data magnetically stored over half a century ago could still be read! The valley in the 1980s used to have many shops assembling components together. Most of the computer companies were merged. The photograph below shows a collection of assorted personal computers used in a variety of applications. The Stanford Research Institute gave the first public demonstration of the computer mouse, windows, and networking as early as 1968. (Both courtesy of Computer Museum.)

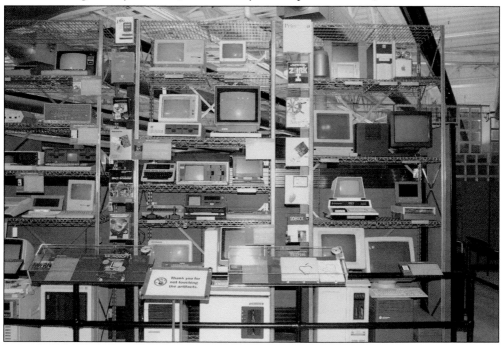

Silicon Valley played a major role in the development of the Internet, as shown in this exhibit. Seeding money provided the means to develop Internet technology. In 1995, Netscape was only 16 months old. The stock went public, and it raised $2 billion on its first offering day. Cisco Systems is a local provider of key routers and switches used in Internet information technology. The photograph below shows their new TelePresence System. People use that system to conduct online conferences. Many major Internet companies—including but not limited to Google, Yahoo, and eBay—call Silicon Valley their home. (Both courtesy of Computer Museum and Cisco, Inc.)

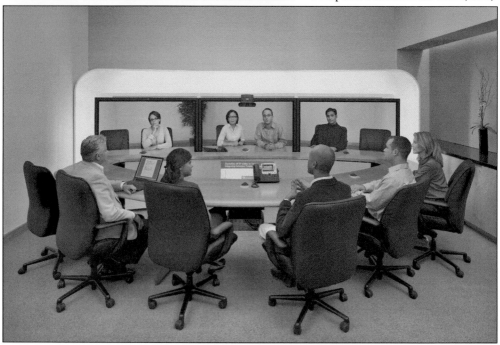

Throughout the 1980s, the valley was fully invested in computer development and manufacturing. The Apple I was assembled in Steve Jobs's garage. It came with 4 kilobytes of RAM with a low-cost 6502 microprocessor. This new computer allowed for a magnetic cassette interface and could connect to a television screen. The retail price was $667, shown in the 1976 advertisement at right. Perhaps there is truth to Apple's name. Not far from Apple's headquarters at 1 Infinite Loop in Cupertino on Mariani Street once stood a west side fruit drier. People used to dice real apples and apricots, not silicon ones. Who could image that a silicon Apple would replace organic ones? (Both courtesy of Cupertino Historical Center.)

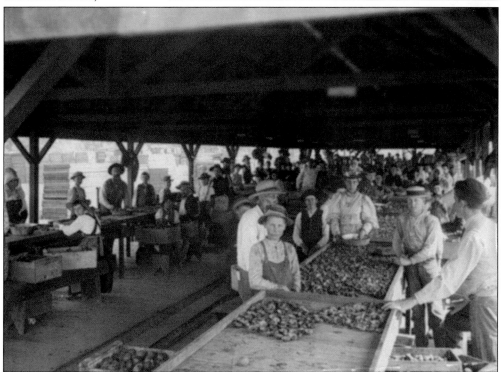

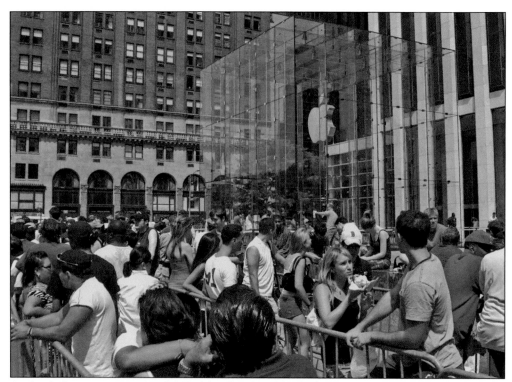

At Apple, Inc., its very successful iPod (media player) and iPhone (multi-application phone), both engineered in Silicon Valley, generated tremendous interest. The photograph above illustrates the "madness" experienced by gadget lovers in New York at the Fifth Avenue Apple store before the release of the iPhone. People stood outside the Apple store the night before to wait in line. Local rivals like Google also came up with the gPhone (shown below) and smart phones. Features of these phones include cameras, Wi-Fi access, map readers, GPS, Bluetooth, text messaging, and music players. (Both courtesy of Paul Tyler.)

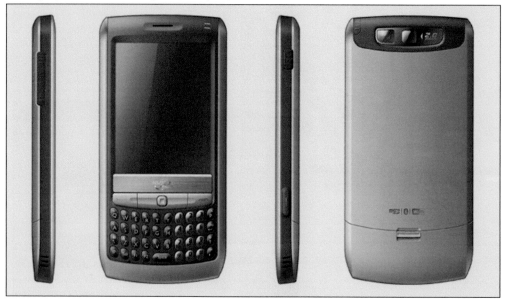

Few realized Silicon Valley was also the test bed for rocket-booster technology. A test facility was built in Coyote by United Technology Corporation for the U.S. Air Force in 1960 to assist America in catching up with Russia in the space race. At top right, rocket boosters with solid propellant were installed nose down on a test bed with a 40-foot concrete base. These boosters were used for the Gemini program and satellites as well as military applications and the Viking mission. When ignited, the 250-ton Titan III-C booster produced 1.1 million pounds of thrust force. The loud noise and flash can be detected as far away as Palo Alto and Salinas. At one launch test, the 911 emergency call center received 600 calls from panicked residents. The technology, however, which used toxic fuel, is considered obsolete, as Atlas liquid-fuel launch vehicles are now in use. Since 1988, the site has been in disuse. (Both courtesy of Kimberly Young-Jolly and Janie E. Young.)

Adobe was founded in 1982 by Xerox PARC researchers. It standardized the world of PostScript language. Adobe is a leading desktop publishing software company. Acrobat, Photoshop, and Frame Maker are some of its more well-known products. With about 2,500 employees on Park Street, it is not far from the original adobe El Pueblo de San José de Guadalupe, which was founded 231 years ago. According to a 2008 *San José Magazine*, there are over 43 billionaires in Silicon Valley with a combined net worth of over $160 billion. Most struck it rich earlier from sale of their stock options. Many invented products that changed the world forever. Most have a technical or business background and a vision. This, along with the mild climate, made the valley very attractive to highly successful people. People like Steve Wozniak, David Packard, Winston Chen, and others later turned their wealth into philanthropy. (Below, courtesy of *San José Magazine*.)

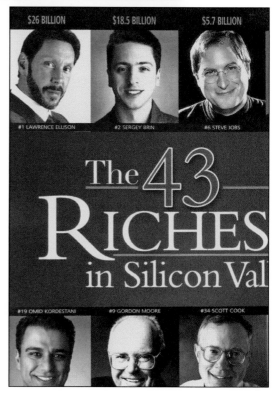

Five

PUBLIC TRANSPORTATION AND SERVICE

Shown here is an 1887 Overland Stage route map. San José was one of the 54 stagecoach stops delivering mail and passengers throughout California. In this area, the coach route followed El Camino Real. There were several stops a few miles apart between Mountain View and 17 Mile House (Fisher House in Coyote), 21 Mile House (Tennant Station), 18 Mile House (Madrone), and other homesteads, finally connecting to downtown San José. In 1896, San José had an electric public transportation system connecting Alum Rock Road westward through Santa Clara as far as Los Gatos and Palo Alto. There were also a total of nine independent interurban rail companies powered by motor or horses. Through consolidation, Peninsular Rail Company was dissolved in 1934. GM took over and tore out the rails for sale as scrap metal to Imperial Japan to enhance its war effort. Today Santa Clara County Valley Transit Authority fills in most of these defunct routes. Caltrans fills in the remaining rail-based stops.

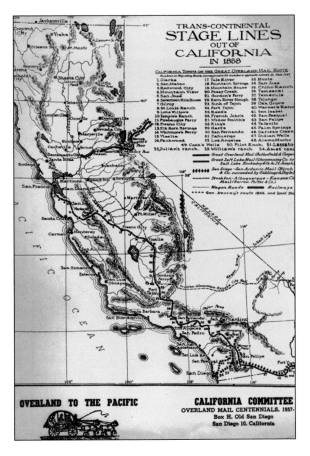

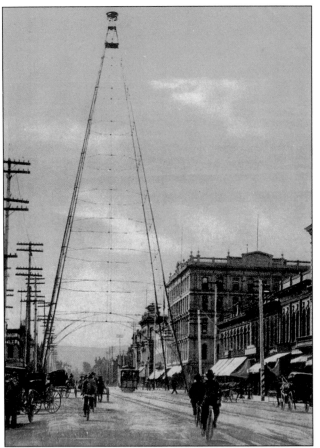

The photograph at left shows common means of transportation in downtown San José in 1910. A trolley (center), followed by bicycles and buggies, is driven on Santa Clara Street. Automobiles would later flood the valley roads for years. To provide a mass transit system to relieve congested roads, the Valley Transit Authority (VTA) resurrected the electric light-rail in 1988, shown below on its inaugural run. Some critics claimed the VTA program in Silicon Valley was not as successful as in other cities, though it does provide a means to get around for those who choose it. Today's light-rail provides racks for bicyclists, reserved seats for handicapped passengers, and a convenient way to get around the valley. (Both courtesy of Santa Clara County Archive.)

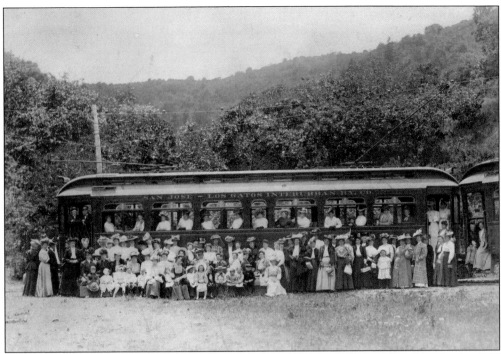

The interurban trolley allows one to ride from one side of the valley to the other. In the 1907 picture card above, women from the King's Daughter Club posed in front of the San José–Los Gatos interurban trolley on their way to attend the Saratoga Festival. The 1925 photograph below depicts Mayfield, a former village next to Palo Alto that had trolley service connecting all the way to the east San José foothills and Los Gatos. Some of the remote areas experienced a voltage drop, causing trolleys to run slowly. The DC motor torque is susceptible to voltage fluctuations, while modern AC motors will not cause trains to slow down. (Both courtesy of California Room.)

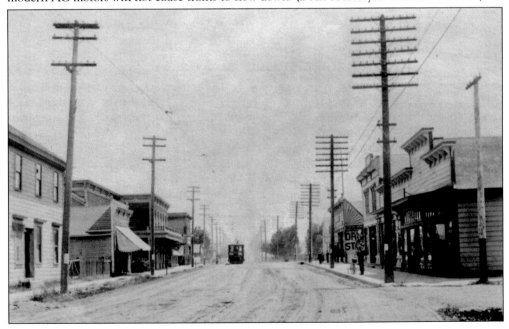

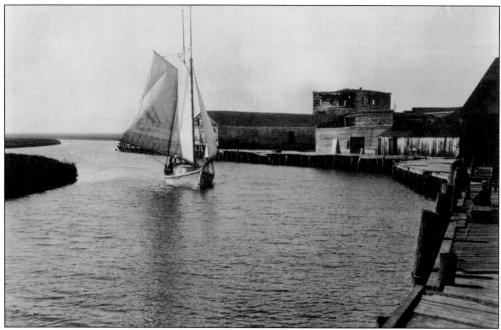

Alviso Port was a bay port used to transport quicksilver, food, and timber needed by San Francisco residents. After 1876, the railroad replaced the role ships played. Alviso was later known for its yachts. New Chicago, a failed proposed development on marshland, would become a wildlife refuge. Today Alviso is a sleepy little village with old buildings along Gold Street reminding many of its colorful past. (Courtesy of Santa Clara County Archive.)

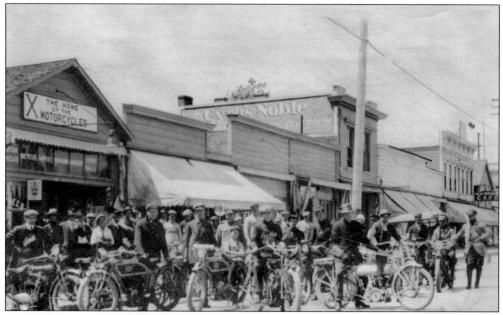

With better engine technology, motorcycles became popular at the dawn of the 20th century. Indian and Harley-Davidson were leaders in motorcycles. Here is a photograph taken in the 1920s in downtown Gilroy on Monterey Road. Many years later, Gilroy would be home to the Indian Motorcycle Company. (Courtesy of Gilroy Museum.)

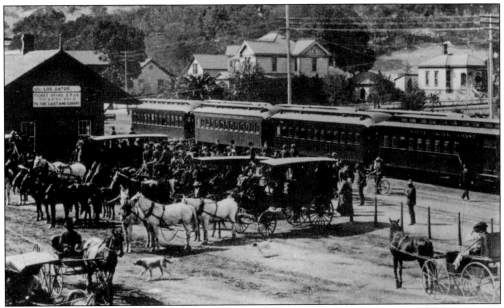

The Southern Pacific Railroad bought South Pacific Coast Railroad in 1887. Both lumber and passengers were transported to and from San José running along Vasona Lake to the present-day Los Gatos Post Office parking lots between Santa Cruz and University Avenues. The narrow-gauge trains would move into the Santa Cruz Mountains. The photograph above shows a view of the Los Gatos train station in 1910. While the freeways like State Route 101 are cluttered with automobiles, the railroads transport commuters en masse. The photograph below is of the 1985 opening of the Caltrain service taking passengers to the Gilroy Garlic Festival. (Both courtesy of a private collection.)

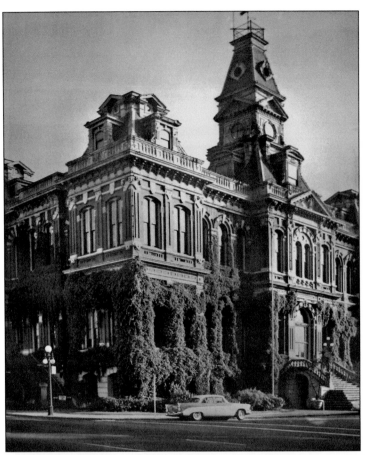

The first San José City Hall stood on 35 North Market Street until 1889. The Victorian-style structure designed by architect Jacob Lenzen served the city for 69 years. This was the center of government activities with a library, jail, and other municipal services all in one complex. It was razed in 1959 at Market and Park Streets where Plaza de Cesar Chavez is today. The postcard shows the old city hall in relation to other nearby buildings. The building at the right serves as the home of San José Museum of Art. Santa Clara Street is in the rear and the street light tower is on the right side. (Both courtesy of a private collection.)

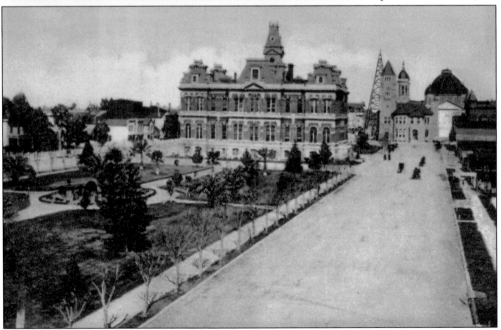

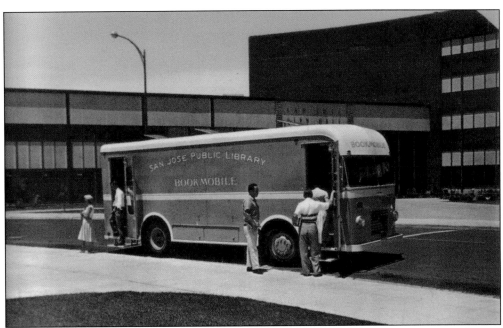

The next city hall was a concrete four-story building (1958–2007) designed for a city of 118,000 residents that had run out of room. Former mayor Susan Hammer advocated a new contemporary city hall with state-of-the-art technology. The result was an 18-story modern office building (285 feet in height) boasting a majestic rotunda with a glass dome (110 feet tall) designed by Richard Meiers. The complex was opened in October 2005 at the cost of $345 million in bond funds.

In 2000, San José voters decided to revamp all city libraries under a $212 million library-branch bond program. The program found permanent homes for roles filled previously by the bookmobiles, leaving one InfoBus for events. Above is a 2006 photograph of the InfoBus at the grand opening of the San José City Hall in front of the rotunda. However, Santa Clara County continued providing library service to isolated areas. Shown below in this 1967 photograph is a bookmobile at the Almaden Avenue garage. (Below, courtesy of Santa Clara County Archive.)

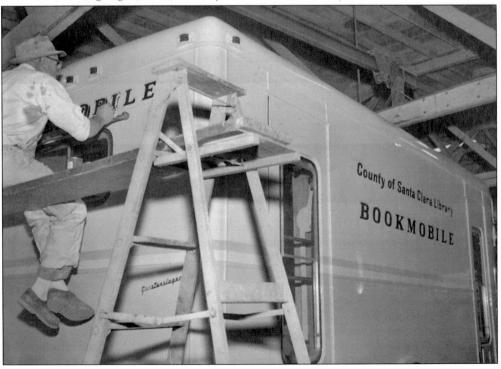

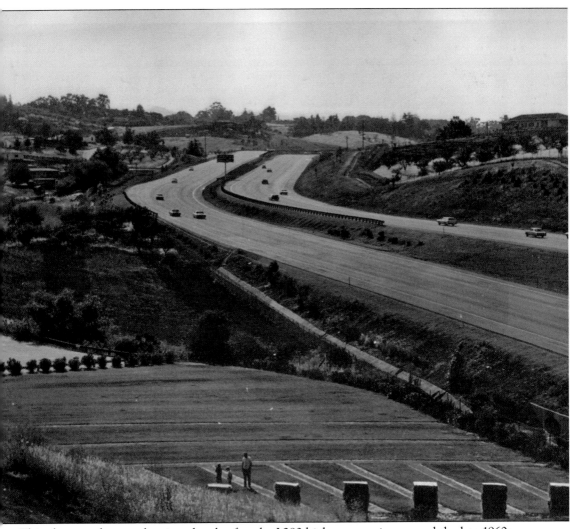

This photograph was taken just shortly after the I-280 highway opening around the late 1960s. I-280 was constructed from Daly City to San José to relieve traffic from Skyline Boulevard. The new highway was named the Junipero Serra Freeway in honor of the Spanish missionary who founded many of California's missions in the 18th century. I-280 had the nickname "World's Most Beautiful Freeway" because of its scenic route though the San Francisco Peninsula. (Courtesy of the Santa Clara County Archive.)

This picture was taken 44 years later on the Foothill Campus. Many trees have been planted along the original highway to reduce traffic noise. The hay farm shown above has been replaced by high-priced estates with overgrown vegetation.

Six

SILICON VALLEY EVENTS

Villa Montalvo, the weekend home to former San Francisco mayor and U.S. senator James Duval Phelan (1861–1930), was built 1912–1914. It was in the foothills of Santa Cruz Mountain in Saratoga. The mansion consists of 19 rooms in two stories and was designed to reflect the style of Italian Mediterranean architecture. This image shows a view from the front lawn looking toward a statue-adorned garden. The grounds encompass around 175 acres. Following Phelan's will, the estate has been a cultural and arts center providing exhibits and theatrical presentations.

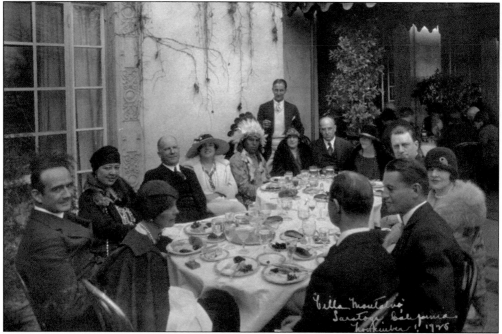

Phelan entertained frequently at the villa with famous writers and artists like Jack London, Douglass Fairbanks, and Edwin Markham as his guests. Some of his guests included military personnel and Native Americans. In 1925, Phelan invited 200 Native Americans for lunch. The delegation was touring the country demonstrating their tribal customs and arts. The lawn today is rather plain, though it used to have rows and rows of beautiful flowers on each side. (Both courtesy of Saratoga Historical Society.)

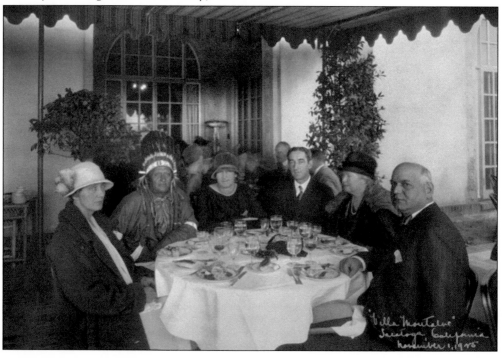

Baseball has traditionally been one of America's passions, with rival teams playing against each other. In Santa Clara County, teams were racially segregated into Anglo, African, Latino, and Asian subgroups until Jackie Robinson played for the Brooklyn Dodgers in 1947. At New Almaden Mines, the Anglos had their own Cinnabars team, shown in the 1897 photograph above. There was also a Hispanic Cinnabars team posed in front of a Chinese Gazebo donated by Marquis Lee Hong-Chang in the name of Emperor Kwang-Hsu. In Heinlenville, near Jackson and Sixth Street, the Japanese Americans formed their own San José team, as shown in the 1925 photograph below. The baseball rules and equipment favored the "inside game," and the game was played more aggressively than today. In addition, the enforcement of new rules governing the size and construction of the ball caused it to travel farther than before. (Both courtesy of a private collection.)

The Chinese New Year has been always the highlight of the year in San Francisco and in other cities around the greater Bay Area. The celebration consists of parades with colorful floats, dragon dances, firecrackers, and beauty pageant contests. The image above shows an undated dragon parade taken in the late 19th century. Young children performed in 2008 for a Taipei grade school class reunion event in Palo Alto, revealing the ancient Chinese secret. In more recent years, the growing Vietnamese population in the valley has sponsored an annual Tet Festival at the Santa Clara County Fairgrounds.

At the end of the 1920s, the Chinese population decreased sharply and many Japanese took up residence near one of San José's Chinatowns, previously known as Heinlenville. The image above is a 1935 photograph taken for the children in front of the 1902 Buddhist temple on Fifth and Jackson Streets. The children were prepared to perform in the Chigo parade, at which there were over 2,000 visitors. According to Masahiko Nishimura, a majority of these photographs were destroyed before the Japanese internment during World War II. The present Buddhist temple was rebuilt in 1937, and the only element remaining from the original is a tree in front of the building. It continues to serve *sangha* (the community). Rev. Honen Takahashi was the first monk in 1907. (Both courtesy of San José Buddhist Church Betsuin.)

Very young children danced at Takio or Obon festivals. In the c. 1937 photograph above, young girls perform dances and music. Some children as young as two or three years old smile while some look scared, and they are not always in unison. Today the highlight of the event is beating the drums to chase hungry spirits and to welcome the living, as shown in the 2008 photograph below. The event shares similarities with the Latino community's observance of el Día de los Muertos. Today participation in San José's Takio or Obon festivals is open to anyone. Drum beating (taiko) with Kachi-Kachi sticks is part of the ritual. The dance, in which everyone moves their arms in graceful gestures, is meant to build harmony. (Both courtesy of San José Buddhist Church Betsuin.)

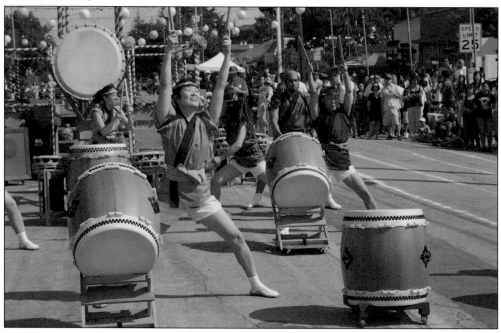

Stanford University today offers 34 varsity sports, 19 club sports, and 37 intramural sports—about 800 students participate in intercollegiate sports. Since 1912, Stanford athletes have won at least one, and as many as 17, gold medals at the summer Olympic competitions. The photograph at right depicts a 2008 football game played between Stanford and San José State University. Volunteer cheerleaders watched from the sidelines as Stanford won 23 to the Spartans' 10. Stanford's football team has been invited to play at the Rose Bowl 12 times since 1901. The picture below shows 1951 Santa Clara University home game played against UCLA. (Right, courtesy of William Cooley; below, courtesy of *Spartan Daily* and Library of Congress.)

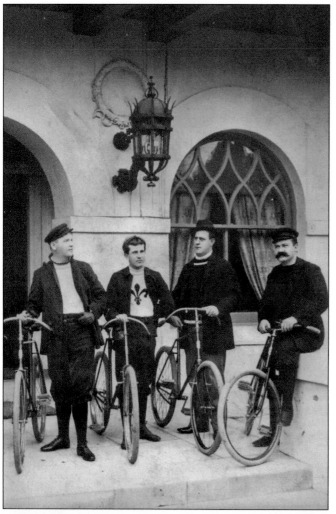

Bicycle riding has always been popular in the valley. By 1890, American manufacturers were producing 1 million bicycles a year. In Santa Clara County, there were no fewer than seven clubs with names like Garden City Wheelmen and Ladies Cycling Club promoting cycling. The upper photograph depicts members from the Santa Clara Bicycle Club. The person second from the right is a Jesuit priest. Years later, awareness of automobile pollution, energy crises, and obesity precipitated interest in the popularity of biking and installation of special bike lanes and bicycle parking. A bicycle race is a popular event. The photograph below shows the 35th annual 30-mile event, which took place in Cats Hill Criterium (Los Gatos) in 2008. Women today also actively participate, and the United States claims over 100 million bike owners. (Both courtesy of G. Dan Mitchell.)

Residents in Silicon Valley work hard and play hard. Starting in 1990, San José has had its own ice hockey team, which called the HP Pavilion home. The 2000–2001 season saw the Sharks put together their most successful season in franchise history with 40 wins, and they became the fifth team in NHL history to improve their point total in five consecutive seasons. Here is a home game at HP Pavilion located in the downtown district. (Courtesy of *San José News*.)

What lies ahead for Silicon Valley? The valley holds a dream for many. Many turned to technology-based products, which forever changed the way people lived. Many argonauts described in the book did not initially strike it rich during the Gold Rush. Others found their niche later. A nearly endless list of successful Silicon Valley entrepreneurs includes the names of Martin Murphy, Packard, Ellison, Brin, and Jobs, among others. The more recent arrivals face ferocious competition and challenges. Good ideas need money and proper timing to execute them. During bad times, such as the 2009 financial crisis, many are just hanging in there. In closing, this 1919 photograph shows cheerful students at San José Normal College as they dance and say good-bye near the tower building. Ninety years have passed since this photograph was taken. How many people back in 1919 could imagine that the Valley of the Heart's Delight would transform into Silicon Valley and opportunity? (Courtesy of California Room.)

Discover Thousands of Local History Books Featuring Millions of Vintage Images

Arcadia Publishing, the leading local history publisher in the United States, is committed to making history accessible and meaningful through publishing books that celebrate and preserve the heritage of America's people and places.

Find more books like this at
www.arcadiapublishing.com

Search for your hometown history, your old stomping grounds, and even your favorite sports team.

Consistent with our mission to preserve history on a local level, this book was printed in South Carolina on American-made paper and manufactured entirely in the United States. Products carrying the accredited Forest Stewardship Council (FSC) label are printed on 100 percent FSC-certified paper.

MADE IN THE